WORLD FILM LOCATIONS BUENOS AIRES

Edited by Santiago Oyarzabal and Michael Pigott

First Published in the UK in 2014 by Intellect Books, The Mill, Parnall Road, Fishponds, Bristol, BS16 3JG, UK

First Published in the USA in 2014 by Intellect Books, The University of Chicago Press, 1427 E. 60th Street, Chicago, IL 60637, USA

Copyright ©2014 Intellect Ltd

Cover photo: *White Elephant/ Elefante Blanco* (2013) © Morena Films/Matanza Cine/Patagonik

Copy Editor: Emma Rhys

A Catalogue record for this book is available from the British Library

World Film Locations Series
ISSN: 2045-9009
eISSN: 2045-9017

World Film Locations Buenos Aires
ISBN: 9-781-78320-358-1
ePDF ISBN: 978-1-78320-340-6

Printed and bound by Bell & Bain Limited, Glasgow

WORLD FILM LOCATIONS
BUENOS AIRES

EDITORS
Santiago Oyarzabal and Michael Pigott

SERIES EDITOR & DESIGN
Gabriel Solomons

CONTRIBUTORS
Gonzalo Aguilar, María Agustina
Bertone, Constanza Burucúa, Javier
Campo, Jack Cortvriend, Andrea
Cuarterolo, Adam Gallimore, Clara
Garavelli, Carlos Giordano, Juan
Grigera, John King, Clara Kriger,
Cara Levey, Adriana Laura Massidda,
Eamon McCarthy, Ramiro Montilla,
Carolina Orloff, Mariana Oyarzabal,
Santiago Oyarzabal, Joanna Page,
Mariano Paz, Michael Pigott, Natália
Pinazza, Paula Porta, Martín Rejtman,
Carolina Rocha, Lucía Rodríguez Riva,
Samanta Mariana Salvatori, James
Scorer, Fernando Sdrigotti, Ana Silva,
Luciana Zorzoli

LOCATION PHOTOGRAPHY
Santiago Oyarzabal and Michael Pigott
(unless otherwise credited)

LOCATION MAPS
Greg Orrom Swan

PUBLISHED BY
Intellect
The Mill, Parnall Road,
Fishponds, Bristol, BS16 3JG, UK
T: +44 (0) 117 9589910
F: +44 (0) 117 9589911
E: info@intellectbooks.com

Bookends: Photo: Oyarzabal and Pigott
This page: *Tetro* (Kobal)
Overleaf: on set of *Rapado* (Photo: Martin Rejtman)

CONTENTS

ACKNOWLEDGEMENTS

The editors wish to acknowledge the
help of the Humanities Research
Centre and the Institute of Advanced
Study at the University of Warwick,
the series editor Gabriel Solomons,
and Adriana Massida, Martín Rejtman,
Gustavo Taretto, Ezio Massa, Julio
Zarza, and Diego Scarpello for help
at various stages of the project. John
King for generosity and persistent
encouragement, the ever-ready PA
Denise, Mariú and Juan, Ale and Marce,
and all of the Oyarzabal family for their
aid and welcome. Mariana Oyarzabal
translated the Spanish texts. We would
also like to give a special thanks to our
contributors for their efforts, insights
and commitment.

SANTIAGO OYARZABAL
AND MICHAEL PIGOTT

INTRODUCTION

World Film Locations *Buenos Aires*

OFTEN PRAISED AS 'the most European of the Latin American cities', the *Reina del Plata*, or Queen of the (Río de la) Plata, Buenos Aires is a city of important contrasts – often more so than its own people, the *porteños*, wish to acknowledge. It is a city of massive wealth and of massive poverty, of European culture and indigenous American tradition, a city of international investment and political division, of Hiltons and shantytowns, a city of rifts, breaches, overlaps, invisibility and public demonstration.

Both ends of the social spectrum brush shoulders in many districts – even the renewed Puerto Madero (symbol of the 1990s neoliberal modernization) lies next to a *villa miseria* (shantytown). Such juxtapositions symbolize a city that both divides and integrates, that can maintain blatant wealth differences, but also integrate poorer, darker-skinned newcomers into the very heart of the urban landscape. And there is even more to Buenos Aires: beyond the Riachuelo river and the Av. General Paz – the two boundaries that demarcate the administrative limits of the CABA (Ciudad Autónoma de Buenos Aires, or what used to be known as the Capital Federal) – is Gran Buenos Aires, the suburban outskirts that extend for miles in every direction. In this book we have chosen to include films made both within the city proper, and amongst its many distinctive suburbs. Both areas are not only essential to the city's identity, but the differences, interactions and ideals that arise from their coexistence are also intricately intermingled into the everyday life of the city.

Cinematic representations of Buenos Aires during the twentieth and twenty-first centuries reveal not only a cosmopolitan city, a 'city of lights', but essentially one with deep roots in both the cultures of multiple waves of immigrants and settlers, and those of the pre-colonial indigenous population. In many of the films included in this volume we see specific urban locations employed in attempts to think through, and deal with, persistent problems posed by the ideologies and material consequences of modernization, and the long-lasting effects of poverty, inequality and exclusion.

Looking now at the collection of scenes and locations selected by our contributors, a few suggestive patterns are evident. Many of the locations are streets, corners, crossings, plazas. Buenos Aires is a city lived on the street. Football stadiums, bars, tango, parks and shantytowns all reveal the city outdoors as a space of socialization, and where passions are lived. If anything, these locations and themes do conform to stereotypes about the city and the *porteño* people. However, perhaps to overturn these stereotypes, there happens to be no scenes in San Telmo or Recoleta, two of the better known, most touristic attractions of the city.

Buenos Aires is also depicted as a fantastic, slippery, Borgesian location – evinced by its facility for becoming other cities, such as 'Aquilea' in *Invasion* (1969), 'Oran' in *The Plague* (1992), and 'Darwin City' in *Condor Crux* (2000).

The book itself functions as a place of encounter between the Anglo and the Hispanic/Latin American academic communities, an exciting blend of film, urban, literary and cultural studies scholars, from across oceans. ✢

Santiago Oyarzabal and Michael Pigott, Editors

BUENOS AIRES

Text by
JAMES
SCORER

City of the Imagination

IN AN APT DISCOVERY for one of the world's great modern metropolises, in 2008 an original version of the 1927 film *Metropolis* (Fritz Lang) was found in the Museo del Cine in the Argentine capital. The fact that Buenos Aires had been sheltering this uncut reel of Fritz Lang's groundbreaking dystopian urban masterpiece for some eighty years was highly appropriate for a city that, ever since its rapid expansion and industrialization at the turn of the twentieth century, has constantly refashioned its own image on the big screen. Like most modern cities, as part of that long history of cinematic reimaginings, Buenos Aires has been variously filmed as a locale of promise and of hopes dashed, of revolutionary possibility and political oppression, and of economic liberty and social inequality. It has served as a synecdoche for the nation and as a symbol of the insuperable breach between the capital and the Argentine interior (or even its own outskirts). And it has functioned as both a *fin-de-siècle* Paris of the southern hemisphere and a truly Latin American megalopolis of the twenty-first century. Like all urban imaginaries, such filmscapes have influenced the way Argentines and foreigners alike think through and inhabit Buenos Aires.

Argentine film-makers, then, have regularly turned to the city as a means of exploring social, political and cultural issues. Even in its early years, Argentine cinema put the city on-screen, including the working-class and immigrant neighbourhoods of the urban south, though it was not until the 1930s that local productions gained ground against US dominance of the film market. The introduction of sound in particular fuelled demand for films that used both recognizably local forms of Spanish and the urban realism of city streets. To some degree those same streets were cinematic victims of the film policies of the first Peronist government (1946–55), when state subsidies, film quotas and censorship encouraged a glut of studio dramas that relied predominantly on innocuous interior spaces. But one of the great contributions of Peronism was to transform Buenos Aires into a socially and politically contested space. With debates growing in the 1960s and 1970s about the social role of cinema, left-wing film-makers presented the city not just as a site of oligarchic values, military repression and neocolonial cultural imperialism but also as one of revolutionary possibility. Film-making and screenings were often clandestine, turning urban cinematic production and consumption into a potentially political act. The 1976–83 dictatorship brought an abrupt end to such cinematic activities, violently clamping down on both the city and its culture. Even with the return to democracy in the 1980s, film struggled to recover its earlier vibrancy and the urban cinematic did little more than depict a city in decline and adrift.

In recent years, however, on the back of renewed state funding and a new cinema law (implemented in 1995), Argentine cinema has experienced an internationally recognized revival in terms of quantity, quality and variety. With that resurgence Buenos Aires has returned as the prevailing locale for thinking through social, political and cultural relations. But if in the past

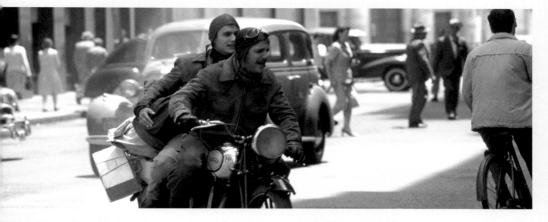

Above © 2004 FilmFour, Wildwood Enterprises, Tu Vas Voir Productions
Opposite © 1985 Historias Cinematograficas Cinemania

film-makers used national architectural icons such as the Obelisco or the Casa Rosada to represent the city, films are now more likely to ignore such landmarks, creating and contextualizing dramatic conflict by using locales ignored by cinema for much of the 1980s and 1990s. The result has been a rich display of urban life in film, captured via location shoots that use neighbourhood restaurants, shantytowns, city streets, and areas of the city located far from the centre.

In that sense, film-makers have highlighted – via this encyclopaedic cinematic gaze – how Buenos Aires itself remains a contested space, caught between a variety of political and financial interests. The city's historic and ongoing reputation as a leading locale for film production in the shape of studios, production companies, film schools, festivals and cinemas, means that it is immersed in transnational flows of funding, local and international screenings, and urban imaginaries themselves. The City Government generates considerable income from such global interactions, a result of competitive filming costs, high-quality production teams, and the visual appeal and versatility offered by the city's colonial, neoclassical, art deco, modernist and postmodern architectural histories. Indeed, Buenos Aires is often listed as one of the top filmmaking destinations in the world, especially because it can act as a double for so many other locations. Commercial advertising, which makes a considerable contribution to that popularity, is often not interested in Buenos Aires at all, but rather a generic Latinized urban metropolis or a stand-in for another implied cityscape.

Cinemagoing itself has also been affected by such developments. If, in the early days of Argentine film, cinema was widely patronised by the working classes, tickets are now much more of a luxury: in 2013 it was estimated that about 22 per cent of Argentineans earned less than $2,000/month, whereas a cinema ticket at a multiplex cost about $50. Simultaneously, many historic cinemas have failed to withstand recent trends in urban regeneration, being either demolished (Cine Capitol) or transformed for other uses (the Cine Teatro Gran Splendid became a bookshop, the Cine Metro a hotel, the Cine Ambassador a shopping gallery).

But the city's enthusiasm for cinema, both in terms of production and consumption, has not been dented. In 2000 Buenos Aires accounted for approximately 65 per cent of cinema ticket sales in Argentina and the city's cinematic public continues to patronise a wide range of screenings of both local and international productions, contemporary and historic, not just at multiplex cinemas but also at the Cosmos, the Espacio INCAA Km 0, MALBA (Museo de Arte Latinoamericano de Buenos Aires) and BAFICI (Buenos Aires Festival Internacional de Cine Independiente). As a result it is hard to find a more cinematic city, perhaps not in the iconic sense of other global metropolises, but as a highly charged urban imaginary that fuels the film industry and continues to inhabit – and be inhabited by – the everyday life of its dwellers. ✢

In recent years, on the back of renewed state funding and a new cinema law (implemented in 1995), Argentine cinema has experienced an internationally recognized revival in terms of quantity, quality and variety.

TANGO AND THE CITY

Text by
JOHN KING

TANGO IS SYNONYMOUS with the development of Argentine cinema, and tango offers a particular mapping of Buenos Aires, with its *arrabales* (outskirts of the city), its *conventillos* (working-class tenements), its *guapos* (hoodlums), its modest houses in the less affluent parts of the city, its particular street corners (Suárez and Necochea in La Boca), its cafes and its downtown bars, cabarets and dancehalls (*milongas*). This mapping is mainly to be found in tango lyrics for, in the laconic words of one of its most famous poets, Enrique Santos Discépolo, tango is a 'sad thought that can be danced'.

We are accustomed to the Hollywood appropriation of the dance, which punctuates films such as *True Lies* (James Cameron, 1994), *Scent of a Woman* (Martin Brest, 1992), *Mr and Mrs Smith* (Dough Liman, 2005), *Frida* (Julie Taymor, 2002), *Shall We Dance* (Peter Chelsom, 2004) and many others, a contemporary interest that has its remote origins in the Rudolph Valentino dance sequence in *Four Horsemen of the Apocalypse* (Rex Ingram, 1921). In most of these movies tango is depicted as a sensual, passionate dance, usually with a controlling male dancer. Tango lyrics tell different

stories. Here is a world of violent men, at home in their *bulín* (pad) with their mothers and *los muchachos* (the boys), their knife wielding friends in the tough outskirts of the ever expanding migrant city. Their harmony is destabilized by women who seduce and then abandon, who leave their humble origins and head to the downtown tango bars and nightclubs, leaving the men singing into their lonely cups in the neighbourhood cafe. Women can be ideal figures of comfort for men, usually mothers, but they are also the prostitutes of the white slave trade, from Eastern Europe, or more particularly in tango lyrics, from Paris. In tango, the pleasures of the night are contradictory: they are seductive but they are insecure and there is no certain way home. Melodrama in Argentine cinema adopts this narrative pattern, but softens the sardonic, unforgiving, tone. The main plots of these melodramas usually trace young women who, naively or by trickery, leave the *arrabal* for the bright lights of the centre, usually manipulated by rich men, for, in these accounts, the rich are always untrustworthy pleasure seekers. But, unlike in most tango lyrics, redemption in the movies is possible. Women get home and might find the embrace of an honourable man. Men who leave the neighbourhood to seek fame and fortune, but find success empty, can return to their *bulín* and their mothers, and often the girl next door is still waiting for them.

The first actuality film to capture the dance was entitled *Tango argentino* (Eugene Py, 1900) and an early fictional feature from 1915, *Gaucho Nobility/Nobleza gaucha* (Eduardo Martínez de la Pera, Ernesto Gunche and Humberto Cairo), telling of a pure girl imprisoned in the city by an evil landowner, featured dance scenes filmed in the most famous cabaret of the time, the Armenonville. Early attempts to add a tango score to movies through records were largely abandoned as tango orchestras began to play in the balconies and orchestra pits of the main downtown cinemas.

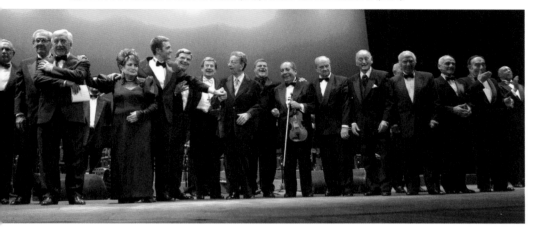

José Agustín 'el Negro' Ferreyra was the most prolific director of the silent era and his *The Girl from the Arrabal/La muchacha del arrabal* (1922) was accompanied at its opening by the leading tango orchestra of Roberto Firpo. Going to the movies in 1920s Buenos Aires was much about going to listen to tango played in movie theatres. With the coming of sound, music and comedy were the ways in which fledgling Latin American cinemas could try to compete with Hollywood. And here tango led the way. Many early sound movies were often mere vehicles for singing as many tangos as possible. Hollywood recognized the appeal of the vernacular and for several years tried to make their own Spanish-language movies, enlisting the great tango singer Carlos Gardel to star in a series of movies produced in North American and Paris studios, with such titles as *Arrabal Melody/Melodía de arrabal* (1932), *Downward Slope/Cuesta abajo* (1934) and *The Day You Love Me/El día que me quieras* (1935). Even though Gardel was killed in a plane crash in 1935, he remains the touchstone for tango song: 'cada día canta mejor' ('he sings better every day') is a popular phrase and there is always a lit cigarette in the hand of his statue in Chacarita Cemetery. Tango and tango melodrama (for this music provided the *melos* to the somewhat formulaic plots) remained dominant throughout the 1930s and 1940s, in films starring singer Libertad

In the 1980s, following the bleak Argentine military dictatorship of 1976–83, tango was used as a metaphor for describing political exile, displacement, loss and return.

Lamarque amongst many others.

With the advent of what has been termed the new Argentine cinema of the late 1950s through to the mid-1970s tango played a much less significant role as directors turned their backs on melodrama and looked to tell either more directly political stories or else to explore middle-class anomie in the style of the French New Wave cinema. But in the 1980s, following the bleak Argentine military dictatorship of 1976–83, tango was used as a metaphor for describing political exile, displacement, loss and return. Gardel's tango lyric from 'Mi Buenos Aires querido': 'My beloved Buenos Aires / when I see you again / there will be no more sorrow or forgetting' took on a new significance in two films by Fernando Solanas, *Tangos, the Exile of Gardel/Tangos, el exilio de Gardel* (1985) and *The South/Sur* (1988), both of which deal with external and internal exile and revisit the streets, bars and neighbourhoods that are the stuff of tango.

In more recent years, from the mid-1990s to the present, there have been successful tango films made by film-makers from outside Argentina (Sally Potter's *The Tango Lesson* [1997], and Carlos Saura's *Tango* [1998]), whilst at home the interest in tango is evident less in feature films and more in documentary production, the most successful of which has been *Café de los maestros* (Miguel Kohan, 2008), a film that reunites in concert the great musicians of classical Argentine tango (and was produced by two of the most influential figures in recent Argentine film and music, Lita Stantic and Gustavo Santaolalla). Buenos Aires remains the city of tango in the movie imagination. ✢

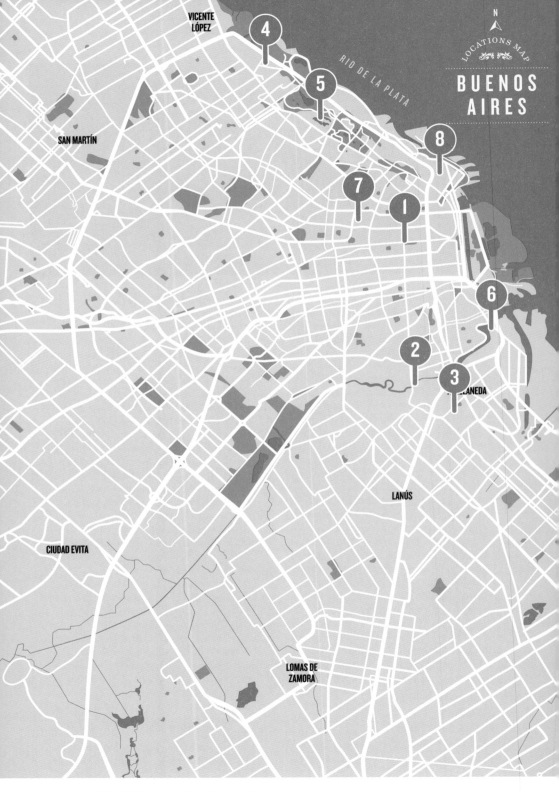

BUENOS AIRES LOCATIONS

SCENES 1-8

maps are only to be taken as approximates

GAUCHO NOBILITY/NOBLEZA GAUCHA (1915)

Congreso de la Nación, Entre Ríos 50

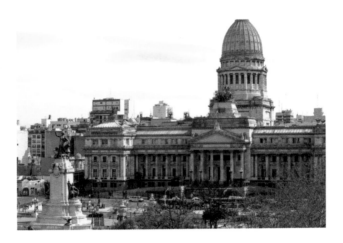

THE SUCCESS OF *Gaucho Nobility*, the first blockbuster of Argentine cinema, may be attributed to its compelling depiction of types and customs, its originality, and its use of realistic locations. The long-standing contrast between idyllic country life and corrupt town life, which for many years characterized local productions, gives way not only to a nostalgic and picturesque view of the rural, but also to an exaltation of the modernizing progress of Buenos Aires. The camera focuses on the city centre, where the political power and latest architectural developments are concentrated. During a key scene, Juan (Julio Scarcella), the gaucho, and his faithful friend Don Genaro (Celestino Petray), an Italian immigrant, travel from the country to the city in order to rescue a young *paisanita* (peasant), kidnapped by the owner of the *estancia* (estate) where they both work and live. Astonished by the size of the city, both arrive at the Plaza de los dos Congresos, just opposite the parliament, one of the newest buildings in the city. With pride and wonder, the naïve Don Genaro states that this 'big house', symbol of the opulence and rapid development of Buenos Aires, must have cost at least 40,000 pesos. As the machine sets the new tempo of the city, the film pays homage to movement and speed. This is evident at the end of the scene when the two *paisanos* desperately try to catch a moving tram, an action that symbolically manifests the paradox of trying to keep up with the times while preserving the traditions and values of a local culture threatened with extinction. **Andrea Cuarterolo**

Directed by Eduardo Martinez de la Pera, Ernesto Gunche and Humberto Cairo
Scene description: Juan and Don Genaro travel to Buenos Aires
Timecode for scene: 0:39:38 – 0:43:20

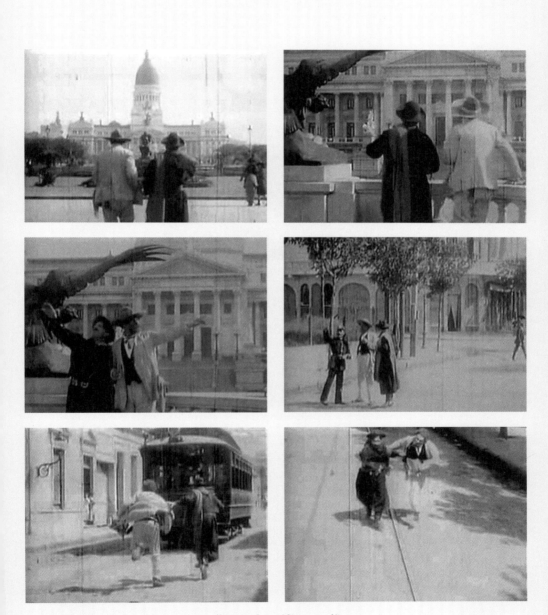

LA VUELTA AL BULÍN (1926)

LOCATION The bank of the Riachuelo, Puente Victorino de la Plaza, Barracas

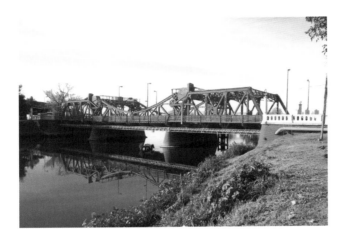

BASED ON THE homonymous tango by Pascual Contursi and José Martínez, *La vuelta al bulín* is a humorous depiction of the misfortunes suffered by a *guapo del arrabal* (hoodlum of the outskirts) abandoned by his wife, who has surrendered to her lover's promises of a life of luxury. Nevertheless, as in most of Ferreyra's films, these stereotypical characters and schematic plot are just an excuse for the display of the true essence of his work – a portrayal of an original and unique iconography of the suburb, in this case represented by the southern quarter (La Boca, Barracas). Profiting from his skills in painting and scenography, Ferreyra manages to capture the humblest profile of the city, focusing his attention on the heart of the *arrabal*: the *conventillos* (tenements), cafes and cabarets associated, by then, with vice and prostitution. Ferreyra captures these places with ascetic realism and even plants his camera in some of the actual settings, revealing a universe that was mostly invisible in the Argentine cinema of the time. Towards the middle of the film, in one of the few scenes shot on location, two *malevos* (thugs) engage in a violent quarrel at the Riachuelo bank, which is interrupted by the arrival of the police. This minor scene serves Ferreyra as an excuse to show the real borough, with its dirty, stinking waters and dissipated life of its inhabitants. As is the case with many of his films, these minor details allow him to achieve a more realistic approach to urban life, a marked characteristic of his unequalled style.
�15 *Andrea Cuarterolo*

Directed by José Agustín Ferreyra
Scene description: Two 'malevos' (thugs) have a violent quarrel by the bank of the Riachuelo
Timecode for scene: 0:09:00 – 0:11:00

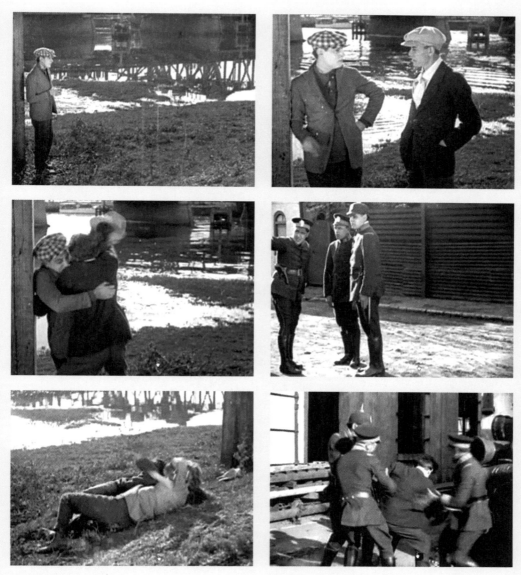

Images © 1926 Ferreyra Film

THE THREE AMATEURS/
LOS TRES BERRETINES (1933)

LOCATION

*Estadio Libertadores de América (Independiente's stadium),
Bochini 751, Avellaneda District*

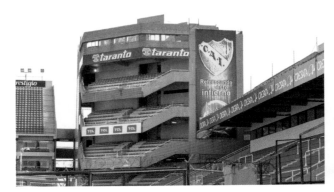 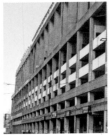

BASED ON THE play of the same name, this film is about the life of a *porteño*
(Buenos Aires resident) family ruled by the three Argentine passions of the
time: tango, cinema and football. A product of Lumiton studios, the movie
consciously displays the technical advances in cinema (it was one of the
first sound films made in Argentina), and also intends to show us a modern
Buenos Aires. We are presented with large avenues, great buildings, the
parks and lakes of Palermo, heavy traffic and crowded streets. These images,
together with Duke Ellington's music, tell us that this is one of the most
modern cities in South America. The father of this *porteño* family resists
these obsessions but he is eventually defeated: his statement, 'I can't take
it any more!' triggers a Sunday procession that finishes at the stadium of
Independiente de Avellaneda. When the players enter the football field, the
crowd cheers their team. Wide shots show passionate spectators. Entering the
stadium seems to take forever and the protagonists are stuck in the middle
of the crowd. It is almost impossible to breathe, only heads can be seen,
there are no gaps. Finally, the lamp post seems the only available viewing
point. While the film might have a wider project of representing a modern
Buenos Aires, these images of the south persist through the century and are
repeated endlessly even today when the stadium has gone through several
remodellings that have altered its face forever. **⚬Samanta Salvatori**

Directed by Enrique Telémaco Susini
Scene description: Going to the football match
Timecode for scene: 0:50:38 – 0:54:05

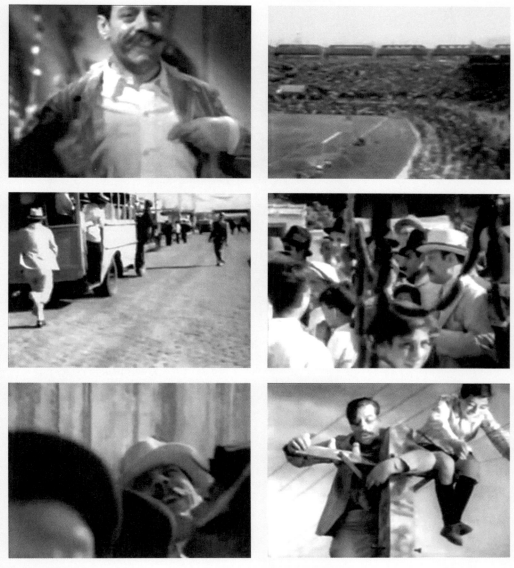

Images © 1933 Lumiton

RAGGED FOOTBALL/PELOTA DE TRAPO (1948)

LOCATION *Estadio Monumental (River Plate's stadium), Av. Figueroa Alcorta 7597, Núñez*

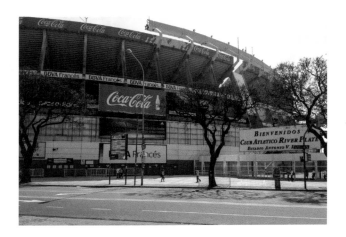

AT THE END OF *Ragged Football*, having made up his mind, the protagonist Eduardo Díaz (Armando Bó) views the goal in an empty Estadio Monumental for one last time before leaving through the tunnel for a quieter life with his lover. The film is a tribute to football and its folklore, a portrait of the passionate feelings the sport awakens in Argentina. Based on a script by *El Gráfico* journalist Ricardo Lorenzo (known as 'Borocotó') and starring several real players led by Guillermo Stábile, director Leopoldo Torres Ríos – father of Leopoldo Torre Nilsson – achieved an extraordinarily popular success with this film during the years of the Juan Domingo Perón presidency. In the story, raised-in-poverty Eduardo Díaz is a dazzling amateur player who quickly becomes a professional and is soon called upon to play for *la selección*, the national team. Some of the film's most important sequences take place in 'El Monumental', the symbol par excellence of the national team, especially since the 1978 World Cup. Images of Eduardo dribbling in the field and scoring, fans cheering his name, and commentators praising his skills are sprinkled generously throughout the film. *Ragged Football* generated the name *sacachispas* (literally 'spark-making') for a traditional brand of children's football shoes (produced by Alpargatas), which became yet another national symbol in Argentina. Today, the football club Sacachispas – actually founded by Borocotó after the film's success – competes in the Primera C division.
↝Ramiro Montilla and Santiago Oyarzabal

Directed by Leopoldo Torres Rios
Scene description: Eduardo takes one last look at the goal
Timecode for scene: 1:44:00 – 1:45.53

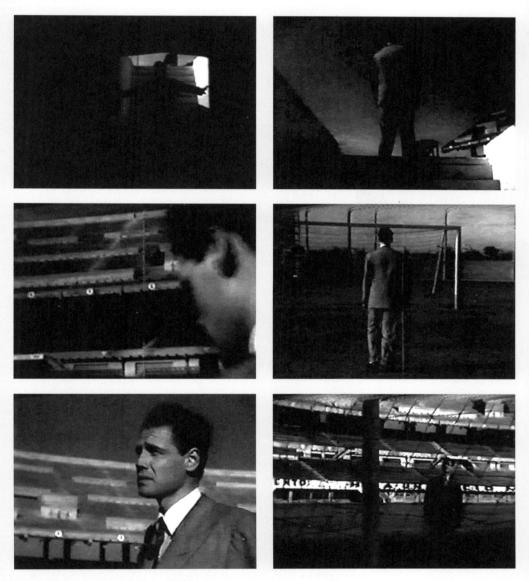

Images © 1948 Sociedad Independiente Filmadora Argentina

HARDLY A CRIMINAL/
APENAS UN DELINCUENTE (1949)

Hipódromo Argentino de Palermo, Av. del Libertador 4101

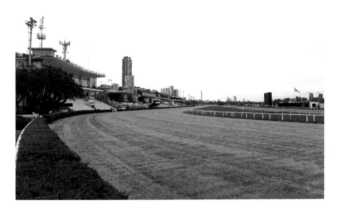

'**THIS IS A STORY ABOUT THE CITY...**' reads a title at the beginning of
the movie, just before we see a montage of several city landmarks. Around
3 million people lived in the capital at the time of shooting, and Buenos
Aires was the most vibrant Latin American city, appealing in its luxuries
and pleasures, but also alienating with its feverish and hysterical pace.
Hardly a Criminal, with its realistic touches, places emphasis on the perilous
dynamism of modern Buenos Aires, the film-makers making the innovative
decision to shoot in the streets and on location around the city, at a time when
much of Argentine cinema was studio-bound. It tells the story of an ordinary
man, José Morán (Jorge Salcedo) who, fed up with the low salary he receives,
decides to take up swindling in the hope of amassing a fortune. A central
scene takes place in the Hipódromo Argentino de Palermo, one of the oldest
(built in 1876) and most famous racetracks in Latin America, in the wealthy
neighbourhood of Palermo, an especially green part of the city. Here Morán's
fate is decided when he loses his wages in a horse race, and with it all hopes of
paying his debts by legitimate means. ◆*Clara Kriger*

Directed by Hugo Fregonese
Scene description: *Morán loses all his money at the racetrack*
Timecode for scene: 0:10:12 – 0:10:46

BARRIO GRIS (1954)

LOCATION *Isla Maciel, Dock Sud, Avellaneda District*

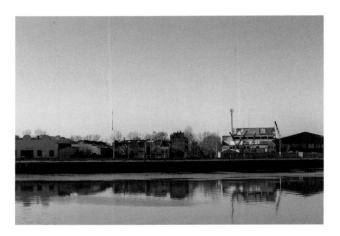

FEDERICO'S (CARLOS RIVAS) voice-over, melancholic and sombre, guides the viewer through a long flashback offering a glimpse of life during the 1930s in one of the many grey and poor *barrios* that appeared at the edges of Buenos Aires city. In this sequence we see him escaping from the police. The images are blurred by the toxic smoke from an acid factory and incineration in an open garbage dump that lies next to the *barrio*. 'Dirty water in the trenches, rotten mud in the streams', is the traditional representation of the underworld of society, where crime and prostitution are common currency. However, the story manages to combine the social problem created by a seemingly incurable poverty, with an individual psychological factor that determines the criminal behaviour of the protagonist. In this frantic, expressionistically stylized sequence Federico seeks refuge amongst the homes, fenced gardens and shacks of Isla Maciel (one of the oldest slums of Buenos Aires). He meets only fear and anger from the residents, who look on as the police, on horseback, give chase through the almost rural setting – their imposing shapes often silhouetted against the bright haze. Finally, Federico has nowhere to go but to climb an electricity pole. ➜ *Clara Kriger*

Directed by Mario Soffici
Scene description: Federico attempts to evade the police
Timecode for scene: 1:25:12 – 1:28:46

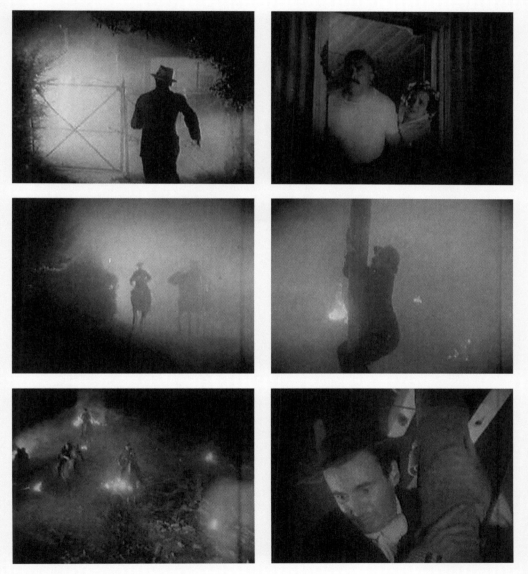

Images © 1954 Cinematográfica Cinco

ABASTO MARKET/MERCADO DE ABASTO (1955)

Abasto Market, located between Av. Corrientes and Lavalle, Agüero and Anchorena Streets

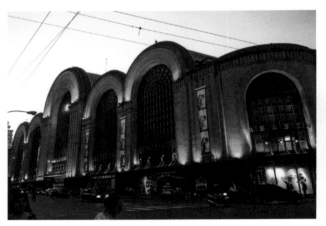

THIS SCENE WAS SHOT within the Mercado de Abasto, which once provided the city with fruit, vegetables, meat and fish. The building, designed by the architects Delpini, Sulčič y Bes was the first built using visible reinforced concrete in Argentina. Opened in 1934, it became the most prominent landmark of a district closely linked to tango. Paulina (Tita Merello) is the mother of the baby shown in the still. She is a single mother and survives on her work at the chicken stall. The market workers, especially Don Lorenzo (Pepe Arias) who secretly loves Paulina unconditionally, help her to bring up the baby. This is a *costumbrista* (popular-realist) movie that brings into focus the solidarity amongst neighbours, a group of workers, most of whom have migrated from the interior of the country. The market offers them a public space in which to settle all kinds of conflicts and negotiations, be they purely commercial or arising from popular passions, such as football and tango. Building upon this traditional framework, the film appeals to the audience by demonstrating the potential to weave a close community that protects the vulnerable. In 1998 globalization reached the Abasto District and the building was recycled into a modern shopping mall. In the years since the significance of the movie has changed. It has become a symbol of, and discourse on, urban history, which helps us view where we come from and where we are going.
⤳ Clara Kriger

Directed by Lucas Demare
Scene description: *The workers entertain the baby at the market*
Timecode for scene: 0:45:33 – 0:47:14

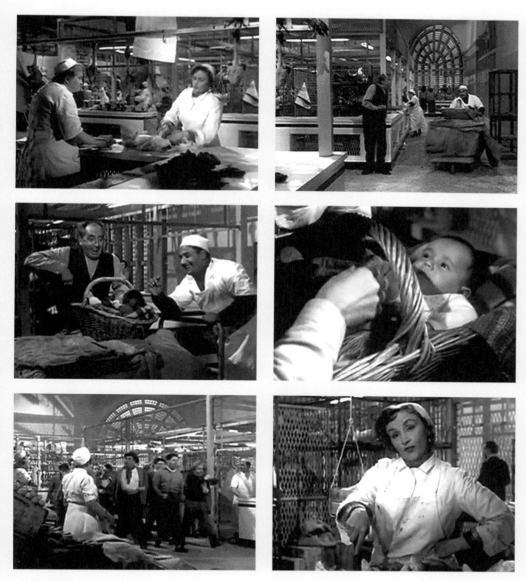

BUENOS AIRES (1958)

Buenos Aires 'villas miseria' (shantytowns)

IN THIS LUCID CRITIQUE of the modern city Kohon plays with a counterpoint between the developed, machine-like city centre of Buenos Aires and the homeplaces of those who prop it up and produce it – the shantytowns. The late 1950s was a moment in which development, embodied by modern architecture and international investment, was expected to solve the pressing housing shortage of Argentina. However, Kohon's *Buenos Aires* is a Manichean world in which it becomes clear that housing is still a great problem. An advertisement for middle-class apartments – of a type that populated the newspapers of the time – is used to emphasize how the fruits of such celebrated development were shared in a painfully unequal way. By underlining the habitation conditions of workers, Kohon takes a strong position in a key debate in Argentina, in which shantytown residents are seen as indolent by some groups and accused of 'immorality'. The film acutely challenges this assertion through its use of a leaflet containing official 'moral' propaganda. 'Sí, señor, yo vivo aquí' ('Yes, sir, I live here') is the only dialogue in this short film, repeatedly declared by three workers whose daily routine the film depicts; this statement heavily condenses Kohon's critique. The words are intercut with images of a heavily-graffitied wall, bearing the names of election candidates, being white-washed. In a context where the gap between poor and wealthy was widening, and where the most popular political party (Peronism) was proscribed from competing in elections, the painting-over may call into question the legitimacy of the advertised candidates.
⊷Adriana Laura Massidda

Directed by David José Kohon
Scene description: 'Sí, señor, yo vivo aquí' ('Yes, sir, I live here')
Timecode for scene: 0:10:31 – 0:11:35

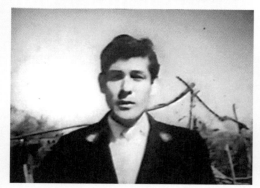 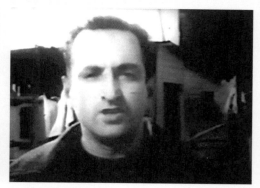

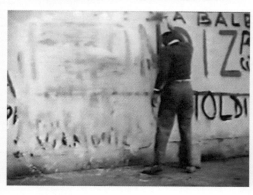 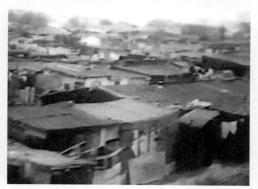

FROM DARK TO LIGHT

Text by
CONSTANZA
BURUCÚA

The Cinema of the Transition to Democracy

THE FIRST ARGENTINE FILM to be released in 1983, the year that culminated with the return to democracy and the reinstitution of civilian rule, was Fernando Ayala's documentary *Buenos Aires Rock*. A record of a public concert that took place in November of 1982, the film opens with a sequence in which four iconic Argentine singers of the period jam together in a small room, at night. The lyrics of the song that they are singing, 'El rey lloró', provide the continuity for an opening sequence that then shows the same four performers on a big stage in the open space of a park, at dusk, and that finishes with the film's credits over a wide shot of the same stage in plain daylight, while young people begin to populate the adjacent field. Knowingly or not, in the wake of what was perceived at the time as a new beginning, these images presented the Argentine public with some of the most prevalent and recurring tropes of the cinema of the period: the return from the darkness of the recent past into the light of a then

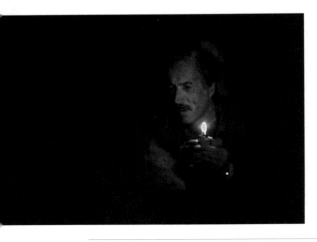

promising future and the re-taking of the public sphere after so many years of forced silence. And, as the main protagonist of this new time and its cinema, the city of Buenos Aires was also re-emerging.

Prior to the end of the dictatorship and due to imposed censorship, a very few films had dared to offer any kind of resistance or to convey a sense of what it meant to live in fear. Some addressed this problem by articulating their narratives in terms of metaphors of silence. Such is the case in Mario Sábato's *The Power of Darkness/El poder de las tinieblas* (1979) and Adolfo Aristarain's *Time for Revenge/Tiempo de revancha* (1981): in both films, the city of Buenos Aires is portrayed as a threatening labyrinth, in which the protagonists are constantly being followed and spied upon. Whilst featuring landmark buildings of the urban skyline, both films also exposed a city partly reduced to rubble. In *The Power of Darkness*, we see the Edificio Barolo (also prominently showcased in Juan Carlos Desanzo's *En retirada* (*In retreat* [1984]), and in *Time for Revenge* the skyscrapers of the Retiro area, buildings commonly associated, in the cinema of the period, with the corporate world that had benefitted from the questionable favours of the regime. Thus, if on the one hand the sight of demolition unmasked and directly alluded to the shortcomings of the many grandiloquent projects of urban modernization initiated after 1976 but eventually left unfinished (a network of highways across the city is one example), they also worked as a means to evoke the idea of a city in ruins.

Much like the city, the film industry was largely decimated after the 1976 military coup – censorship, black lists, persecution and exile

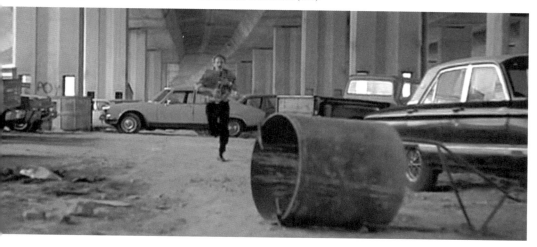

had crippled the sector. The industry's subsequent recovery would be a key component in the reconfiguration of the public sphere during the transition to democracy. In line with the cultural policies of the elected government of Raúl Alfonsín, which acknowledged and promoted the medium's potential to effectively communicate (domestically and internationally) the aims and the ethos of the young democracy, and conforming to the widely accepted understanding of the time under military rule as the 'dark years', the Argentine cinema of the subsequent period staged the transition to democracy both in terms of the dark/light metaphor and around the symbolic recuperation of the city of Buenos Aires. Emblematic in this sense is Miguel Pérez's documentary *The Lost Republic/La república perdida* (1983), a film in which the idea and the image of the republic is almost literally conflated with that of Buenos Aires. By means of copious and thoroughly researched archival material, the city is portrayed as Argentina's unequivocal political epicentre. But more interesting than this is the recurrent inclusion of images of the city's citizens – 'the people', in the film's vocabulary – taking to the streets to demonstrate at various moments in history. The film uses these images to convey ideas about democracy, civic liberties and the need for historical memory, establishing them as essential pillars in the reconstruction of the republic.

Some of the best known and most representative feature films of the period deal directly with the recent past and its traumatic legacy. Many of them privilege nocturnal settings – *Children of War/Los chicos de la Guerra* (Bebe Kamin, 1984), *En retirada*, the early sequences of *The Official Story/La historia oficial* (Luis Puenzo, 1984), *The Owners of Silence/Los dueños del silencio* (Carlos Lemos, 1987) – or inscribe within their narratives, in a more or less optimistic tone, the arrival of a new dawn, with films such as *The South/Sur* (Fernando Solanas, 1988) and the late and sombre *A Wall of Silence/Un muro de silencio* (Lita Stantic, 1993) finishing on this note. The public space, previously oppressive, was now opened up as the ground on which to begin to come to terms with the recent past. Unsurprisingly, all of these films include sequences in which the street itself – because of the presence of people marching or openly discussing politics, the inclusion of posters, graffiti, etc. – becomes the space where characters are confronted with this past and the need to make sense of it. And while looking at the city with new eyes, some of these films also reveal and uncover the darkest vestiges of the regime. The illegal detention camp and the mass grave become obscure yet now visible spaces in the reconstituted urban landscape (*The South*, *The Owners of Silence*, *The Girlfriend/La amiga* [Jeanine Meerapfel, 1988], *A Wall of Silence*). ✦

The city of Buenos Aires in Adolfo Aristarain's *Time for Revenge/Tiempo de revancha* (1981) is portrayed as a threatening labyrinth, in which the protagonists are constantly being followed and spied upon.

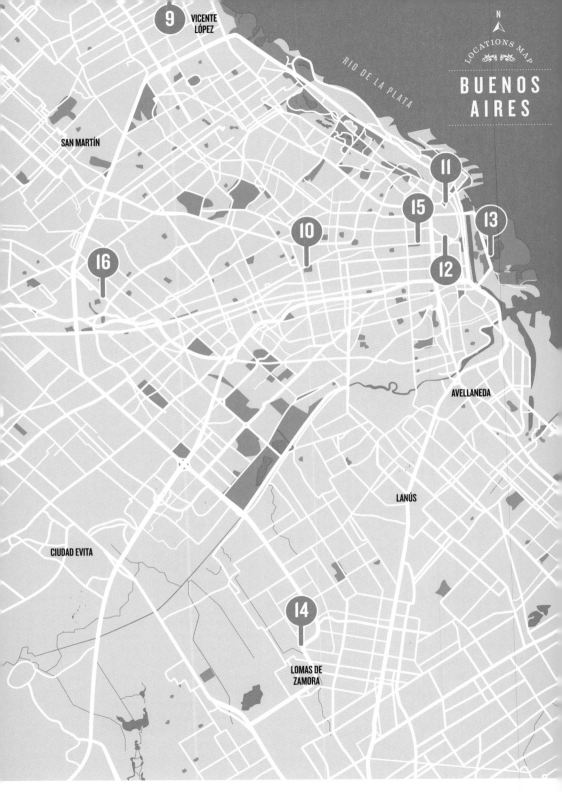

N

RIO DE LA PLATA

9 VICENTE LÓPEZ

SAN MARTÍN

11

15

13

10

12

16

AVELLANEDA

LANÚS

CIUDAD EVITA

14

LOMAS DE ZAMORA

BUENOS AIRES LOCATIONS

SCENES 9-16

maps are only to be taken as approximates

THE BOSS/EL JEFE (1958)

San Isidro Cathedral and the Olivos District, Zona Norte

THE BOSS is a transitional film between two different political eras, as well as between different models of film production (from classic to modern cinema). In the film, these changes manifest as symptoms. After a prologue at the police station, the city is introduced. We follow a strange, fish-shaped truck. From its blaring speakers we hear the popular tune 'Por cuatro días locos que vamos a vivir' ('For four crazy days we will live'). The truck passes by the statue of Jesus Christ in the Plazoleta Obispo Aguirre at the side of San Isidro Cathedral. It disturbs the peaceful streets of the wealthy Olivos neighbourhood (a locality just beyond the northern border of the City of Buenos Aires), and finally stops at the door of a mansion. We cut to the interior, a sumptuous residence that belongs to Marcelo Soto's family (Leonardo Favio). While his father (Orestes Caviglia) storms around the house slamming windows shut to keep out the noise of the popular music, Marcelo not only re-opens them, but is drawn outside to join these interlopers. The rest of the film takes place on the limits: the crime boss is waiting for them by the river, and the gang meets in Olivos (a locality just beyond the northern border of the City of Buenos Aires) before they go downtown to carry out scams. It is on this frontier, within boundaries that are identified in the first scene, that the film tells the story of a crossing between classes, the decay of *caudillism* (local, often authoritarian, charismatic leadership), and the emergence of another social sector. **◆ Lucía Rodríguez Riva**

Photo © Lucía Rodriguez Riva

Directed by Fernando Ayala
Scene description: Marcelo argues with his father and hits the streets
Timecode for scene: 0:04:35 – 0:09:20

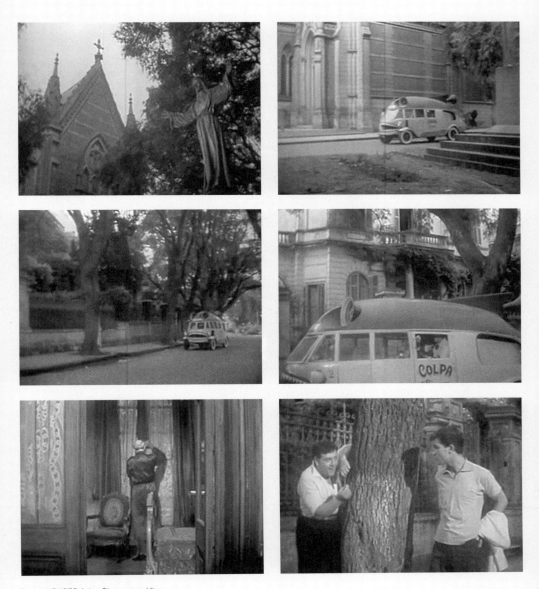

Images © 1958 Aries Cinematográfica

THE PEOPLE AT TABLE 10/
LOS DE LA MESA 10 (1960)

LOCATION *Bar 'La Colón' (now Bar 'El Coleccionista'), Av. Rivadavia 4929*

THE SCENE TAKES PLACE in a Buenos Aires bar, where María (María Aurelia Bisutti) and José (Emilio Alfaro) are seated at a table next to the window. It is their first meeting and María's words – 'I like seeing people passing by' – establish the special boundaries that make this particular table their neutral meeting place in an overpowering city. The permanent flow of pedestrians and cars outside, along a typical downtown street, contrasts sharply with the slow pace inside. This inner, private world is where the couple belongs, whereas the street, and the world outside, constantly threatens to remind them of the social rule they are determined to break: the assumption that a young upper-middle-class woman and a young working-class man should refrain from dating. However, the bar atmosphere is not without flaw; María and José cannot attain complete isolation from the rest of the world, and the half-open blinds remind them of this. Yet the bar successfully distinguishes itself from the classy *cafeterías* where she should feel at home, and also from the lower-end joints that he may frequent. The choice of a bar to tell this couple's story makes us reflect on the role that those spaces have played in the construction of the idiosyncratic identity of the typical *porteño* (Buenos Aires resident). Historically, social actors have met in bars to discuss and act upon politics, culture and sports. As such, this choice of location may be a metaphor for the youngsters' struggle to flout the old-fashioned social rules. **→María Agustina Bertone**

Directed by Simón Feldman

Scene description: José and María's first meeting at the bar
Timecode for scene: 0:20:32 – 0:22:40

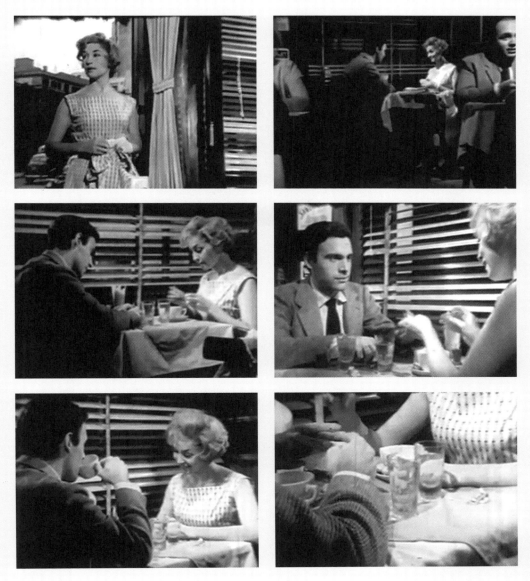

Images © 1960 Siluetas

THREE TIMES ANA/TRES VECES ANA (1961)

Plaza San Martín, in front of the Kavanagh building, Florida 1065

'DO YOU BELIEVE IT IS A CITY?', a journalist asks his office mates, as he looks through a large window across a wide avenue. The reply: 'No, it is a great club of zombies, a camp of ghosts.' This critique of urban life, focusing on the automatic and the repetitive, is the optic through which Buenos Aires is represented in the three short movies that constitute *Three Times Ana*. The city: a site wherein intimacy is diluted by public space and the dizziness of city-life invades privacy. In the selected scene a young couple confess their love to each other in Plaza San Martín. They have a moment of tranquility – birds are singing and the wind moves the branches of the trees. Then they run across the park, down the grassy slope and back into the frantic pace of the city. This is the Buenos Aires fulfilled by cars and buses, the hurried step of transient citizens, the insistent visual demands of advertising and shop windows. Engines and horns sound. Two long shots are enough for a representation that searches not for detail but aims to display the everythingness: the confusion, the mixture, the routinely noisy and chaotic world of the city. In Kohon's film the urban is the substance everyone breathes, where privacy is often lost, but where it is sometimes possible to create a pocket of intimacy. ➡ **Diego Díaz**

Directed by David José Kohon
Scene description: The lovers run across the square
Timecode for scene: 0:22:38 – 0:24:34

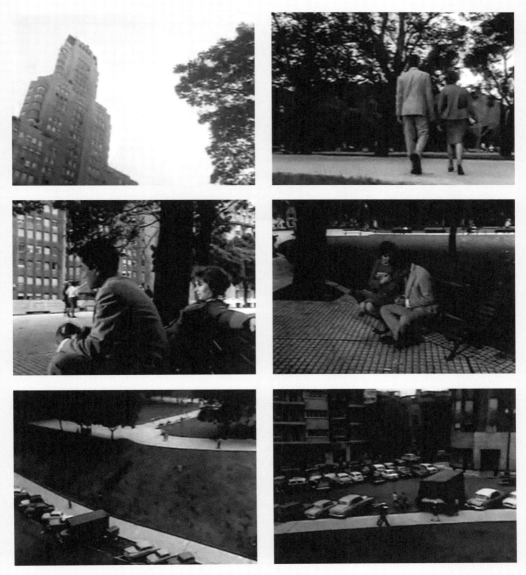

Images © 1961 Marcelo Simonetti

THE HOUR OF THE FURNACES/ LA HORA DE LOS HORNOS (1968)

LOCATION

Microcentro (location image shows the former Banco de Boston, on the corner of Diagonal Norte and Florida Streets)

THE HOUR OF THE FURNACES begins with a long sequence in which the state of affairs of Latin America in the 1960s is summarized using text, photographs and found footage. This is followed by images (of *villas* [slums], rural workers, the elderly) that illustrate the narrative account, providing hard data about the region's low standards of living, distribution of land ownership, deaths by curable diseases, and Buenos Aires' role as 'epicentre of neo-colonialism'. The 'objectivity' vanishes as the reporter defines the city as 'cradle of the great middle class, the small-timers and eternal whiners of a perturbed world for whom the revolution is necessary but impossible [...] – head office of the church, the army, the legislative and executive powers, and 80 per cent of criminal organizations'. While the images show buildings that are representative of these powerful institutions (Palacio de Tribunales, Congreso de la Nación, Teatro Colón, Edificio Kavanagh and the building once known as the Banco de Boston, which was also the symbolic target and epicentre of the 2001 protests), the spoken narration expounds a rhetoric that contrasts sharply with the objective tone that had defined the first part of the film. For Robert Stam (p. 259), the selected sequence, which describes the city in a bitter tone, is 'dipped in acid. Rather than exalt the cosmopolitan charm of the bustling energy of Buenos Aires, the commentary disengages its class structure', in a procedure similar to Luis Buñuel's irreverent satire of Rome in *L'Age d'or* (1930). **⊷Javier Campo**

Directed by Octavio Getino and Fernando Solanas
Scene description: The Port City (a critique of Buenos Aires)
Timecode for scene: 0:25:56 – 0:28:22

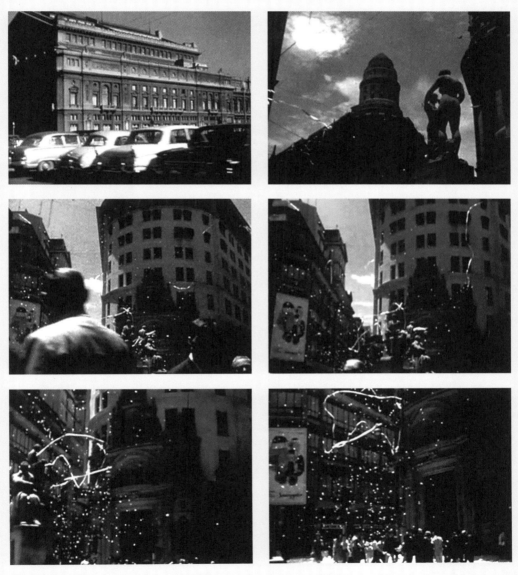

Images © 1968 Grupo Cine Liberación/Solanas Productions

INVASION/INVASIÓN (1969)

Costanera Sur

AQUILEA IS AN IMAGINED CITY from 1957, besieged by a powerful invasion force, and resisted by a few men and women who do not consider themselves heroes, yet dutifully defend the city to the last, not suspecting that the battle is endless. Based on a plot by Adolfo Bioy Casares and Jorge Luis Borges, *Invasion* tells a story that takes place in a version of Buenos Aires during the 1960s. However, the spatial and temporal references are ambiguous, the city's spaces are disordered and reformed, mixed with imaginary space to invent a new, or perhaps alternative, metropolis. The film foreshadows the violent years in Argentina. In the beginning the factions are introduced. A truck collects a mysterious cargo at the port and heads for the exit where two guards are murdered, and continues on its way along the Costanera Sur (southern waterfront). A tango marks the rhythm, as the enemy advances over Aquilea and the fighting begins. Images of the real city are intercut with an imaginary map. Today the Costanera Sur looks out across a sea of greenery and wild landscape, as if it were the aftermath of a cataclysmic re-ordering of the city's topography. This is, in fact, land reclaimed from the Río de la Plata that is now protected as an ecological reserve. **➩Samanta M. Salvatori**

Photos © main picture: Carlos Ruiz Badilla (panoramio) / detail: Oyarzabal and Pigott

Directed by Hugo Santiago
Scene description: The invasion of Aquilea city
Timecode for scene: 0:03:45 – 0:06:41

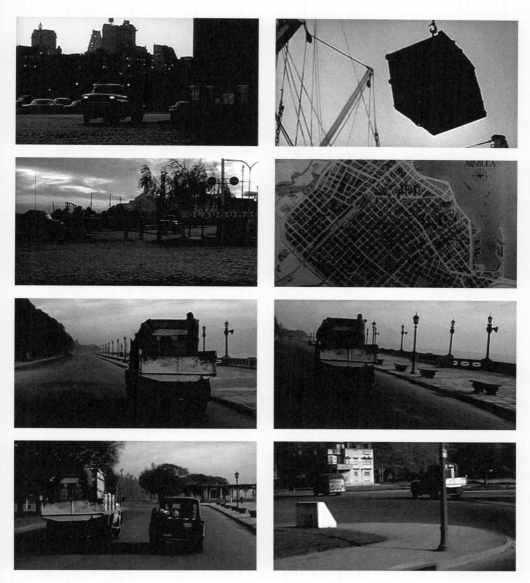

THE TRAITORS/LOS TRAIDORES (1973)

Camino Negro (Pres. Juan D. Perón), Lomas de Zamora District

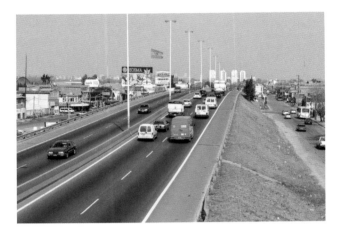

IN THE SUBURBS of Buenos Aires we see several handwritten flags. 'No more crumbs', 'Long live working class unionism' and 'Long live Perón' are the placard slogans supported by several dozens of workers behind barricades. They are all young men, protesting against the current dictatorship and the proscription of Peronism, and have taken over the factory in which they work. Trade union officials arrive and try to persuade the occupants to opt for a strategy of 'reconciliation' to avoid any confrontation, but the workers reject the Union strategy and accuse them of betraying the working class' interests. The sequence, which takes place in a typical industrial enclave of the kind that lined the Camino Negro Road in Lomas de Zamora, powerfully presents trade unionists and rank-and-file workers as antagonistic. This is the 'treason' that runs through the film, narrating the personal journey of Roberto Barrera (Víctor Proncet), leader of the UOM (Metalworkers' Union), from his humble militant origins in a Buenos Aires workers' tenement to his later betrayal of worker interests for personal enrichment. The film, one of the most important examples of Argentine political fiction, portrays a crucial aspect of popular uprising in the 1960s and 1970s, when several workplace union committees radicalized and became autonomous, and rejected the union leadership. The director, Raymundo Gleyzer, who is one of the many who disappeared during the 1976 military dictatorship, was himself a militant and part of this process. **⤖Luciana Zorzoli**

Directed by Raymundo Gleyzer
Scene description: A stand-off between workers and trade union leaders
Timecode for scene: 0:02:50 – 0:05:06

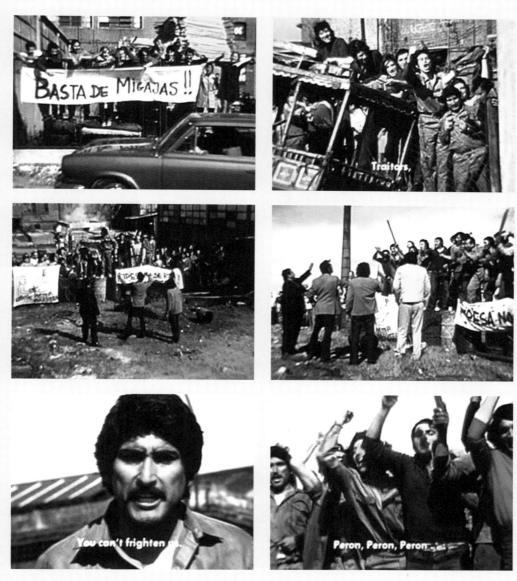

Images © 1973 Grupo Cine de Base

EN RETIRADA (1984)

Edificio La Inmobiliaria, Av. de Mayo 1402/1500

THROUGHOUT *EN RETIRADA (IN RETREAT)*, former paramilitary task force operative Oso (Rodolfo Ranni) lives in two landmark buildings of Buenos Aires: the Edificio La Inmobiliaria, on Av. de Mayo facing the Plaza de los dos Congresos – famous for its facade and its twin red cupolas – and, while in hiding, the building opposite the Obelisco best known for its Coca-Cola billboard. It is actually here, in the city's epicentre, behind the bars of this huge neon signboard, that Oso finds temporary refuge both from those chasing him – his former boss's men and the father of one of his victims – and from a city in which he feels increasingly alienated. Thus, while the people buoyantly open up to democracy, freely expressing their ideas and opinions, Oso cannot help but show disdain, and even contempt, for every manifestation of social and political activism. As a film concerned with a character of the underworld, a man transiting the liminal, it comes as no surprise that some of the urban spaces privileged in Juan Carlos Desanzo's film are the subway and the rooftops of buildings. It is at a subway station that Julio (Julio De Grazia) recognizes Oso as his son's torturer and kidnapper and then restlessly hounds him until the very end of the film, culminating in a spectacular chase across the rooftop of the Edificio La Inmobiliaria, where Oso is eventually shot dead by a precise bullet coming from an unidentified spot. ➻*Constanza Burucúa*

Directed by Juan Carlos Desanzo
Scene description: The rooftop chase
Timecode for scene: 1:18:45 – 1:20:19

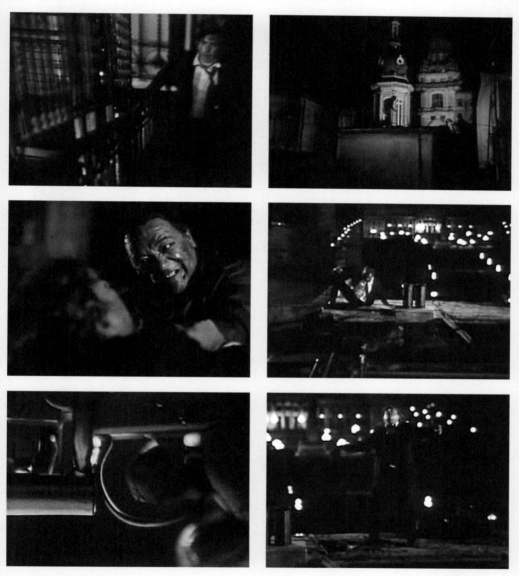

WAITING FOR THE HEARSE/
ESPERANDO LA CARROZA (1985)

Echenagucía 1232, Versalles

ALEJANDRO DORIA'S *Waiting for the Hearse* is set within the universe of the neighbourhood, away from the centre of the city. Its focus is on the pace, culture and humour of the suburban life of the city, rather than the bustle, speed and stress of the urban core (nevertheless, it is not afraid to portray the inequalities as well). The film follows a typical middle-class family, in which (as in its beloved precursor *The Three Amateurs* [Enrique Susini, 1933]) each of four brothers enjoys quite different socio-economic status. This is especially evident in their homes. The film begins in the house of Jorge (Julio de Grazia), which is obviously a modest dwelling. However, it is in Sergio's (Juan Manuel Tenuta) home where the majority of the action takes place, including uproarious fights over who has to take care of the elderly matriarch Mamá Cora (Antonio Gasalla). His house is a typical 'casa chorizo', a structure that was developed in the nineteenth century to more fully exploit the long, narrow plots available in the rigid city block. This architectural form, characteristic of Buenos Aires, consists of a long, thin ground floor in which all rooms are set in a row, and all open out onto a narrow, bright and airy courtyard, producing a specific configuration of the relationships between inhabitants, as well as a number of specifically cinematic potentials for action, movement, drama and in this case in particular, broad comedy. When Mamá Cora, presumed dead, returns home, her family attempt to conceal her funeral preparations. **➻Lucía Rodríguez Riva**

Directed by Alejandro Doria
Scene description: Mamá Cora returns from the dead
Timecode for scene: 1:21:40 – 1:25:42

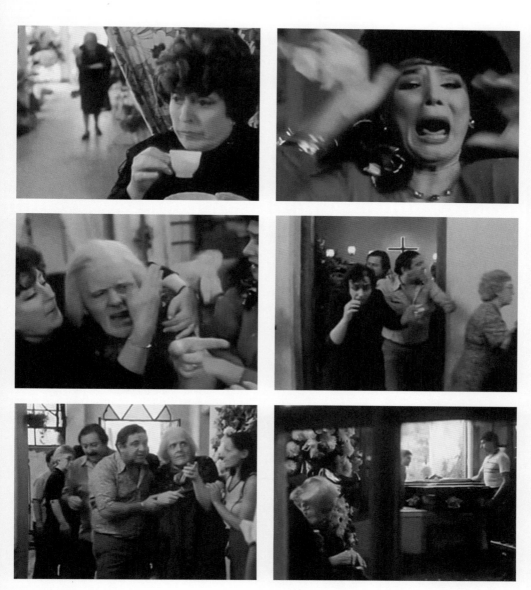

Images © 1985 Rosafrey/Susy Suranyi

SHANTYTOWNS

Text by
GONZALO
AGUILAR

Buenos Aires, the Shattered City

THE *VILLA MISERIA* (shantytown) is an emblematic image of Latin America. A product of peripheral capitalism and of profound inequality, the phenomenon of the *villa miseria* begins in Buenos Aires during the 1930s and maintains a gradual and sustained growth until the present day, in which they have undeniably been incorporated into everyday life and the urban landscape. Their visibility, however, has always been problematic: excluded from tourist postcards, denied or downplayed by politicians and by the population at large (Buenos Aires's *villas miseria* lack the visual presence of Rio's *favelas*), source of frequent shame for their own people, the existence of the *villas* creates disharmony with the image of modernity Buenos Aires has always projected as the 'most European' of Latin American cities. As a result, the presence of the *villa miseria* in the cinema is linked to its conflictive representation. This, perhaps, explains their late emergence in the cinema, almost twenty years after the first settlements.

The *villa miseria* exists in the imaginary as a contrasting phenomenon to the *barrio* (neighbourhood), a *porteño* (Buenos Aires

resident) topic with a long tradition that can be dated back to at least the turn of the twentieth century. In popular culture the *barrio* represents affective ties and the romantic ideal of community – and it has turned into a cult object, to which both tango and poetry actively contributed. The *villa*, on the contrary, does not have poets or singers who sing to it. Unlike the *barrio*, the *villa miseria* is the place where affective and communal ties are irreversibly degraded. Their representation, thus, is always problematic: while on the one hand the 'power' or the State is accused of neglecting the area, on the other, their inhabitants are also shown in conditions of moral squalor, almost inevitably inclined to crime.

Because it is problematic, the representation of *villas* is also a potential object of censorship, for the State and for the population, who would prefer *not to see* them, or to deny their existence. In 1951, during the presidency of Juan Perón, León Klimovsky made *Suburbio*, a story set in a *villa miseria*. Under official pressure, Klimovsky changed the ending to suggest that the settlements were no longer a problem. The title *Suburbio* actually originated in a script Jorge Luis Borges and Ulyses Petit de Murat wrote in the 1930s concerning those *barrios* where bravery and courage prevailed; in the 1951 version, 'suburbia' is an area full of poverty, crime and treason. Although a rapidly growing urban phenomenon during the 1950s, the term *villa miseria* was not in use yet. In this decade the technical term *villa de emergencia* (emergency settlement) appears, and subsequently the more popular *villa miseria*, taken from the title of a 1958 novel by Bernardo Verbitsky, *Villa miseria también es América* (*Villa miseria is also America*).

It is during the post-Peronism period that the *villas* make their breakthrough at the cinemas. In 1958 Lucas Demare's *Behind a Long Wall/Detrás de un largo muro* portrayed a rural family's arrival in the city. They come looking for a bright future,

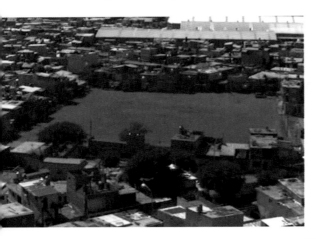

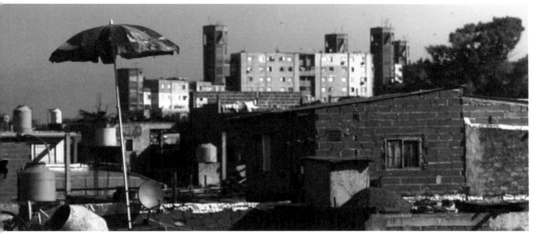

only to find urban misery, and ending up involved in a story of criminality. In this case the *villa miseria* is placed in opposition to the countryside and to the modern metropolis, as seen in long travelling shots of the Kavanagh building, Avenida del Libertador and Retiro Station. As in Leopoldo Torre Nilsson's *The Kidnapper/El secuestrador* (1958), set in the *villas* of the south of the city, and Fernando Ayala's *The Candidate/El candidato* (1959), portraying the settlements in the north (in Bajo Belgrano), these films assert a series of topics that will persist into more recent films such as Pablo Trapero's *White Elephant/Elefante blanco* (2012). There is the vice-ridden character that drags others down with him, the decay of affective ties, the importance of the *punteros políticos* (intermediaries who obtain votes for political parties in exchange for gifts), the demagogic and inefficient presence of the State, and the labyrinth-like configuration of space, full of hidden or inaccessible places.

However, this was not the only mode of representation for the *villas*. In *Buenos Aires* (1958), director David Kohon (an important director of the 1960s generation) offers a merciless representation of society, and criticizes the processes of modernization in general, rather than simply Peronism. While criticizing those in power, the film highlights the pride of the *villa's* inhabitants, as well as its potential in social and political terms. A second shift in representation takes place with Fernando Solanas and Grupo de Cine Liberación's *The Hour of the Furnaces/La hora de los hornos* (Octavio Getino and Solanas, 1968) and *The Children of Fierro/Los hijos de Fierro* (Solanas, 1975), both not only denounce the effects of modernization, but incite the audience to commit politically to end the ignominy of misery. The people of the *villas* are no longer represented in a negative way, and, in fact, the *villa miseria* becomes the place par excellence of popular and political rebellion.

The crisis of 2001 propelled a series of new representations of the *villa*, especially in the field of documentary. Nevertheless, stereotypes have persisted. In *White Elephant*, for instance, stereotypes are everywhere, which becomes more evident the more the film attempts to avoid them. Once more we see the *villa* as a dead-end labyrinth, a shantytown priest as a morally impeccable character, and drugged zombie-like kids who will never go to school. In a striking reflection on this trend, Federico León and Marcos Martínez's film *Stars/Estrellas* (2007), tells the story of a villa resident who starts up a casting company. The *villeros* (*villa* residents), pretend not to be pretending and perform the stereotypes of the *villa*: acting as 'thieves', 'kidnappers' and 'maids'. What these actors do is to accept the stereotypes, see them as symbolic constructions, and through them, take part in the social scene, with the aim of transforming it. ✤

Unlike the *barrio*, the *villa miseria* is the place where affective and communal ties are irreversibly degraded.

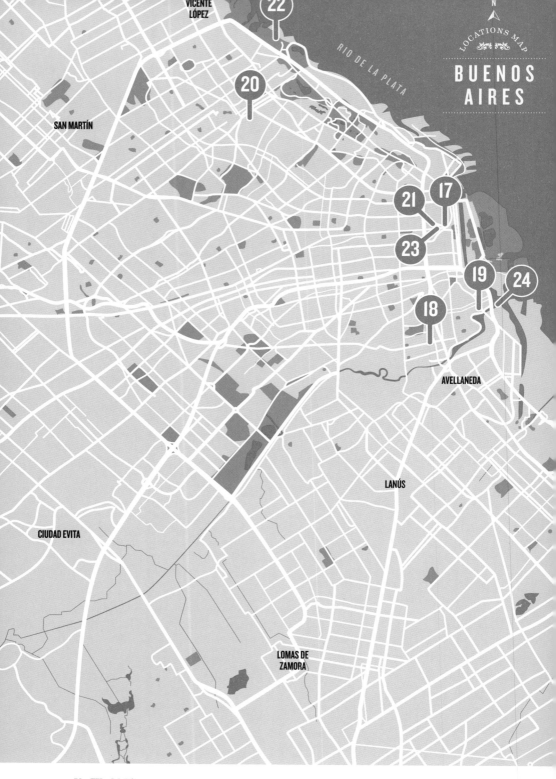

BUENOS AIRES LOCATIONS

SCENES 17-24

maps are only to be taken as approximates

THE OFFICIAL STORY/
LA HISTORIA OFICIAL (1985)

LOCATION > *Plaza de Mayo*

A MILESTONE IN THE HISTORY of Argentine cinema and a film that in many ways harnessed the newly elected democratic government's discursive policies about the recent past, *The Official Story* is also an exemplary text in terms of its re-working of Latin American melodrama. Key to Alicia's (Norma Aleandro) quest to find the truth about the origins of her adopted daughter is this woman's progressive rejection of an oppressive domestic space and her gradual acknowledgement of the world around her. Alicia is positioned and represented in relation to one particularly significant public space – the Plaza de Mayo –, which exemplifies her transition from denial to acceptance. This location is never fully revealed visually, but is metonymically inscribed in the film thanks to the presence of its best-known inhabitants: the *Madres* (Mothers) and *Abuelas de Plaza de Mayo* (Grandmothers of the Plaza de Mayo), known for their tireless quest for the truth about their disappeared children. Thus, the first time that Alicia encounters one of the demonstrations led by these human rights groups, she feels threatened and seeks refuge in her husband's office building and looks on from the safety of an upper floor. Conversely, towards the end of the film, when Alicia is ready to confront the truth, she walks towards the marching crowd, and, even though she does not fully join the demonstration, she actively seeks to connect with her 'adopted' daughter's grandmother, a member of the *Abuelas de Plaza de Mayo*.
↝ Constanza Burucúa

Directed by Luis Puenzo
Scene description: Alicia confronts the demonstration in the Plaza de Mayo
Timecode for scene: 1:37:30 – 1:39:30

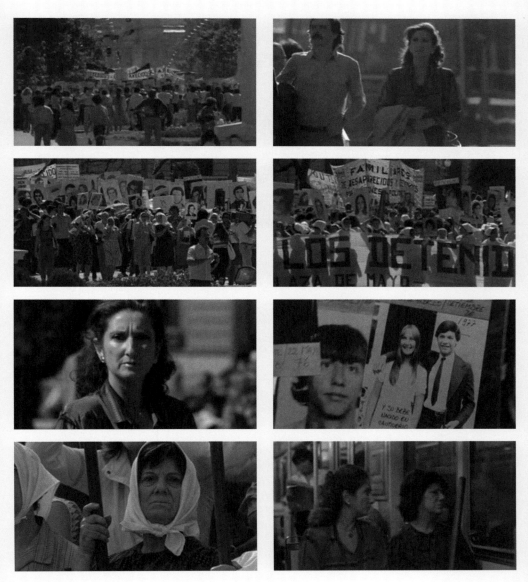

Images © 1985 Cinemania/Historias Cinematográficas

THE SOUTH/SUR (1988)

THE SOUTH MARKS Fernando Solanas's definitive return to Argentina. Following the earlier *Tangos, the Exile of Gardel/Tangos, el exilio de Gardel* (1985), a film mostly shot in Buenos Aires but primarily set in Paris, *The South* is also a story about a homecoming. Freed from jail, where he remained for five years under dubious allegations of political activism, Floreal Echegoyen (Miguel Angel Solá) spends his first night of liberty wandering around the streets of his suburban neighbourhood. As an unlikely *flâneur*, he turns his fears about re-entering his house into an opportunity to revisit the past. The epicentre of his meanderings is the Café Sur, a bar in a corner of a working-class quarter, which the lyrics of the eponymous tango 'Sur' clearly allude to. To construct an atmosphere of Buenos Aires, more than an accurate portrayal of the city, Solanas's film resorts to some emblematic landmarks – the then abandoned Abasto Market, the Riachuelo – but it always returns to the cafe. Very much like the song, the film is also imbued with nostalgia, rendered here through a *mise-en-scène* that privileges a nocturnal palette and expressionistic lighting to underscore the phantasmagoric nature of Floreal's memories. In *The South*'s imagined geography, the downtown is reduced to an indistinct labyrinth where Rosi (Susú Pecoraro), Floreal's wife, hopelessly searches for him following his disappearance. Life, and with it politics, happens elsewhere: after a night of encounters, re-appraisals and street demonstrations celebrating the end of the dictatorship, Floreal is finally capable of reuniting with his wife, while the light of dawn illuminates the Café Sur. •*Constanza Burucúa*

Directed by Fernando Solanas
Scene description: The suburban and the imagined geography of Buenos Aires
Timecode for scene: Location returned to at several points throughout the film

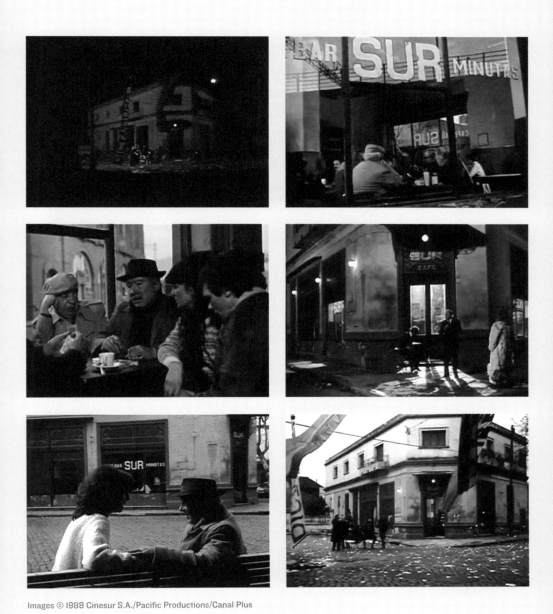

THE PLAGUE/LA PESTE (1992)

LOCATION *Corner of Martín Rodríguez and Ayolas Streets, La Boca*

ORAN, THE NARRATOR tells us, is 'a European city that happens to be in the south of South America'. In this adaptation of Albert Camus's novel, Oran is clearly Buenos Aires in disguise. Perhaps it is more accurate to say that it is the port district of La Boca fictionally expanded to become a fantastic city in its own right. Dr Rieux (William Hurt) narrates an account of an outbreak of the plague, which becomes an excuse for the city government to lock up whoever it likes in a temporary detainment centre in La Bombonera stadium. At the climax of the film, with the city finally released from martial law and quarantine, the sense of elation is broken by the sound of a gunshot. Cottard (Raúl Juliá), an enigmatic taxi driver with links to the underworld and a guilty conscience, has taken it upon himself to become the 'angel of the plague'. From his apartment balcony he picks off passers-by with his rifle. Here the spatial locality of Oran is clear – all of the main characters, though separated, hear the shots and are drawn to the crossing of Martín Rodríguez and Ayolas Streets either as participants or witnesses. Cottard's lesson, which he explains to his final victim Tarrou (Jean-Marc Barr), is that the plague 'will always come back'. The film is unusually faithful to the actual geography of La Boca, and the final shot shows the ambulance turning off Martín Rodríguez onto Av. Don Pedro de Mendoza, with a wide view of the Riachuelo and the Puente Nicolas Avellaneda in the background. ➻*Michael Pigott*

Photo © Diego Scarpello

Directed by Luis Puenzo
Scene description: *The angel of the plague*
Timecode for scene: 1:34:46 – 1:40:25

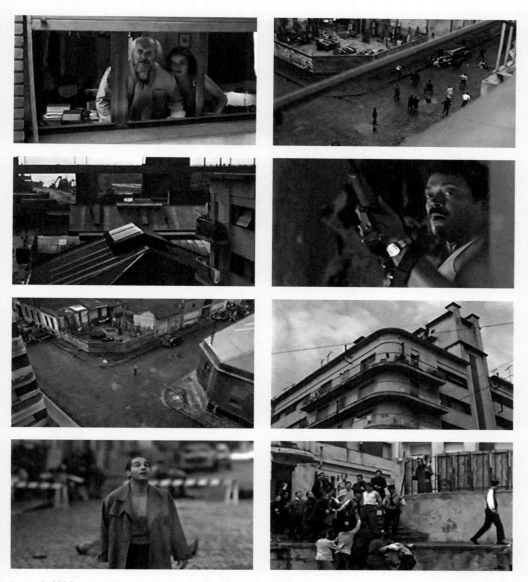

Images © 1992 Compagnie Française Cinématographique/The Pepper-Prince Ltd/Oscar Kramer S.A.

RAPADO (1992/1996)

LOCATION *Plaza Juan José Paso, Colegiales*

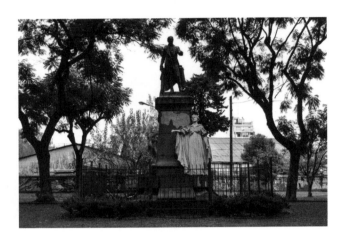

AS REJTMAN HIMSELF has put it, '*Rapado* is a film about economy, in every sense. About balance' (Ricagno and Quintín, pp. 14-15). Lucio (Ezequiel Cavia) has his bike stolen and instead of reporting it to the police he attempts to steal another. The fabric of the film exposes the scarcity of funds at the time of production: barter, fake banknotes, sweets given as change and skyrocketing arcade-token prices populate the narrative. While several elements make evident the galloping inflation in Argentina at the time of making, Rejtman adopts a subtle, relaxed tone. In the selected sequence Lucio and Damián (Damián Dreizik) drink beer and talk about several things (such as the stolen bike), before Lucio's father (Horacio Peña) joins them. They are sitting at the monument in the Plaza Juan José Paso, in Colegiales. Despite the night and the cold, the place feels welcoming: the monument has been 'appropriated' through graffiti, an urban practice that overwrites historical, institutionalized symbols to create new texts and meanings. These stone markers of the official story of Buenos Aires are, today, kept behind railings designed to prevent such attacks. The plaza is a place of encounters and mismatches, and the film captures and memorializes this everyday space that has become flesh and blood in *porteño* (of Buenos Aires) existence. Thus *Rapado* brings the viewer closer to some of the typical customs, spontaneous and reflective, of this culture. ➙ *Paula Porta*

Photo © Marcelo Sarbia

Directed by Martín Rejtman
Scene description: Lucio and Damián discuss the stolen bike
Timecode for scene: 0:18:50 – 0:21:44

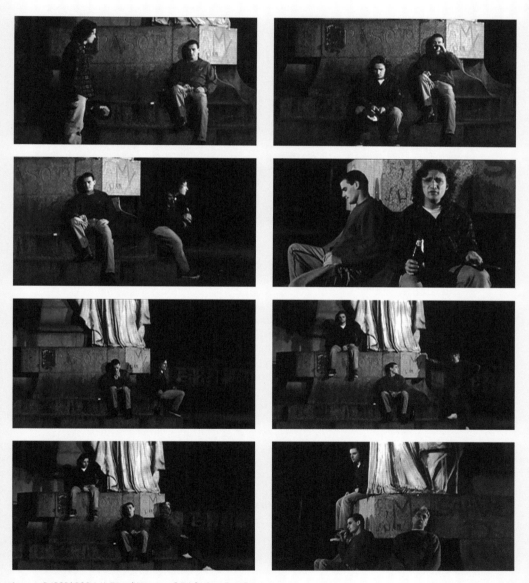

WILD HORSES/CABALLOS SALVAJES (1995)

LOCATION *Torre Pérez Companc building (aka Torre Petrobras), corner of Rivadavia and Maipú*

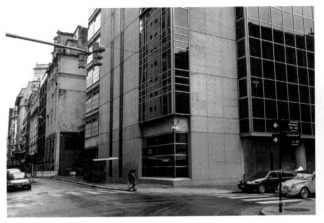

MARCELO PIÑEYRO'S *Wild Horses* was one of the top box office successes of 1995. The film opens with the voice-over of José (Héctor Alterio), who, in black-and-white, is shown walking forlornly around the streets of the financial district of Buenos Aires. His narration explains his decision to act before it is too late. He arrives at a banking company and demands the return of a deposit that had been confiscated, aiming a toy gun at Pedro (Leonardo Sbaraglia), a young yuppie employee, who forcefully denies any wrongdoing by the company, but who, in his attempt to calm José, discovers a hefty booty. Pedro immediately decides to protect the old man and acts as his hostage, providing a human shield that facilitates his escape. The two 'accomplices' flee in Pedro's car, triggering a chase through the chaotic traffic of midday Buenos Aires. Just as they manage to lose their pursuers, José faints and Pedro takes him to a hospital. While Pedro waits, he watches the TV screens in a nearby appliance shop, discovering that their escape was captured by a television crew. Pedro then attempts to negotiate with his boss, but he is faced with an ultimatum that sends the pair on a journey to the liberating and more authentic south. As these characters leave behind the city, depicted as impersonal and artificial, they slowly relax and begin to appreciate the beauty of the places they traverse. ↠*Carolina Rocha*

Photo © Marcelo Sarbia

Directed by Marcelo Piñeyro
Scene description: *The hostage situation at the bank*
Timecode for scene: 0:00:57 – 0:07:59

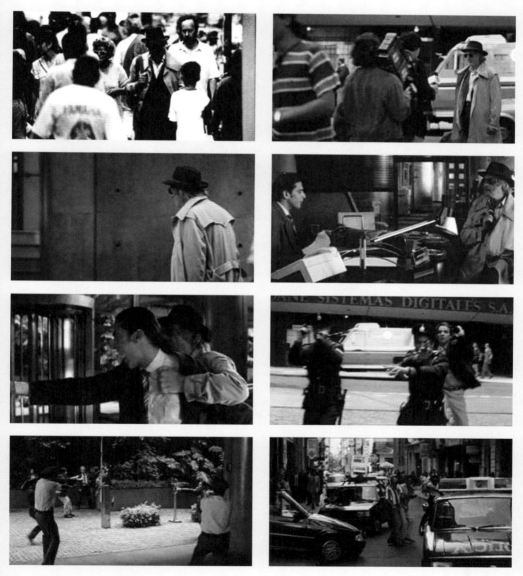

Images © 1995 Mandala/Arena/Artear

MOEBIUS (1996)

Ciudad Universitaria (Universidad de Buenos Aires) and the Buenos Aires underground network (the Subte)

MOEBIUS IS A LOW-BUDGET, independent film which may even be considered a precursor to the New Argentine Cinema. The story takes place almost entirely within the Buenos Aires underground network (known as the Subte). The film was shot on location in stations, train carriages and tunnels, as well as in control centres and depots. When one of the trains goes missing while in transit (passengers included), a young topologist, Daniel (Guillermo Angelelli), is sent to investigate. Early on, the protagonist visits Ciudad Universitaria – the campus of the Universidad de Buenos Aires (UBA). As he leaves, the camera follows him into an elevator. The doors open to reveal a Subte station, located just below the building, named Ciudad Universitaria. It is at this point that audiences familiar with the city realize that this is a fantastic representation of Buenos Aires, since, in reality, the Subte does not reach this area. Further non-existent stations will be seen later on, for *Moebius* is set in a futuristic Buenos Aires in which the underground network has been drastically expanded. Eventually our topologist discovers that one of the underground lines has somehow acquired the properties of a Möbius strip, in which a continuous surface suffers a 180-degree twist. This is what caused the disappearance of the train. The film has been interpreted as a metaphor for the *desaparecidos* (the disappeared) during the 1976–83 dictatorship and, in fact, a wall in one of the stations has been covered with photographs of the missing passengers, clearly echoing the search undertaken by human rights groups. **↦Mariano Paz**

Directed by Gustavo Mosquera
Scene description: Daniel enters the Ciudad Universitaria subway station
Timecode for scene: 0:23:44 – 0:27:19

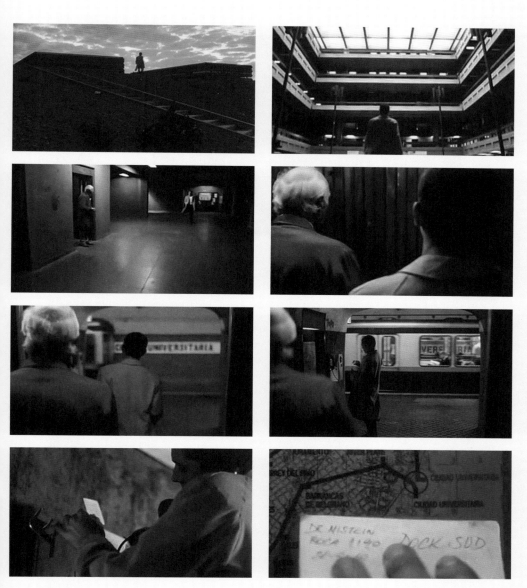

EVITA (1996)

LOCATION *Casa Rosada, Balcarce 50, Plaza de Mayo*

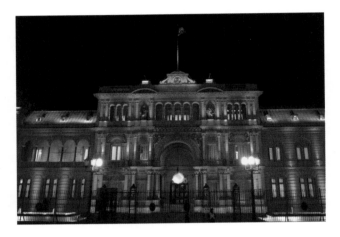

'**DON'T CRY FOR ME ARGENTINA**' is the best-known song from the original Broadway musical of the title, and the correspondent scene at the mid-point of the film version captures Evita's (Madonna) rise from small town girl to First Lady, focusing on her charisma and popularity. From one of the balconies of the Casa Rosada, a triumphant Perón (Jonathan Pryce) introduces his wife to the cheering crowds who are jubilantly waving banners in the Plaza de Mayo below. The scene very cleverly blends the public and the private; moving from Perón on the balcony to Evita preparing to appear, and then during the song itself the crowd scenes are intercut with scenes from earlier in the film charting Evita's own early life, thus reinforcing the links made between her and the people before her. These associations are further extended by the musical references at both the beginning (Evita's funeral) and the end of the film (renouncing the Vice Presidency). The lyrics are made ever more potent through the use of gestures and the exchange between close-ups and very wide shots. Criticism of Perón's regime is not entirely absent from this triumphant scene and is embodied in the figure of Ché (Antonio Banderas). Nonetheless, it undoubtedly marks the zenith of the couple's power. The crowd is enthralled by Evita's words and the setting of the Casa Rosada and Plaza de Mayo underscores her power and places her at the heart of Argentine politics. ↝*Eamon McCarthy*

Directed by Alan Parker
Scene description: Don't Cry for Me Argentina
Timecode for scene: 1:08:06 – 1:13:45

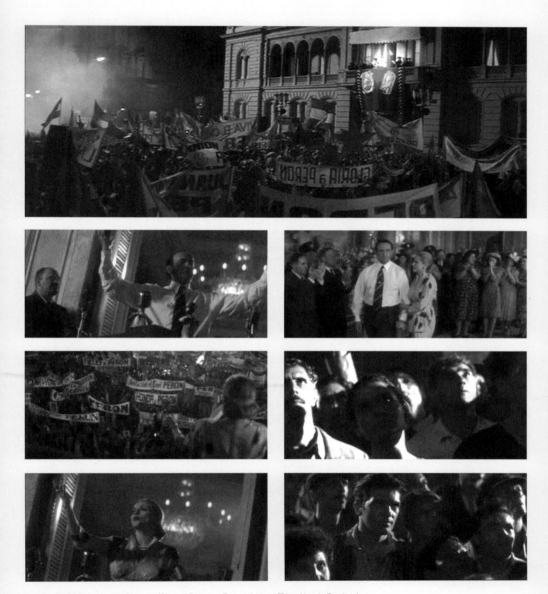

Images © 1996 Hollywood Pictures/Cinergi Pictures Entertainment/Dirty Hands Productions

HAPPY TOGETHER/CHUN GWONG CHA SIT (1997)

LOCATION *Boca del Riachuelo (mouth of the river Matanza-Riachuelo), Dock Sud, Avellaneda District*

HAPPY TOGETHER presents the tumultuous relationship between tourists Ho-Po Wing (Leslie Cheung) and Lai-Yiu Fai (Tony Leung). They find themselves stuck in Buenos Aires – which lies on the other side of the world to their native Hong Kong – trying to earn enough money to reach Iguazu Falls and then fly back to their own country. The selected scene encapsulates the characters' feelings of stasis, both geographically and emotionally. The scene opens with a pool of lightly rippling water, which offers a stark contrast to the recurring motif of the violently crashing Iguazu Falls, emphasizing the stillness of their travels and the lapping waves of their relationship. Ho-Po is revealed to be lying on some flotsam near the city's old port, looking defeated, tired and in pain. The camera rests on his face as the accompanying score, a slower variation on the tango played throughout the film, is mixed with wailing strings that match his agony. The film's surroundings here mark a shift from the clean and exotic tango bars and shabby-yet-charming apartments to a glut of dirt and accumulated rubbish floating on the Río de la Plata. Furthermore, the washed-out blues of the scene contrast with the colour palette of their happiest times together, in which they played football on the sun-drenched streets; all of which indicates that they can no longer be happy together in Buenos Aires. Ho-Ping's scene of distress fades to black, which marks his last appearance in the film. **•+*Jack Cortvriend***

Directed by Wong Kar Wai
Scene description: Ho-Ping's dejection at the Port
Timecode for scene: 0:56:55 – 0:58:51

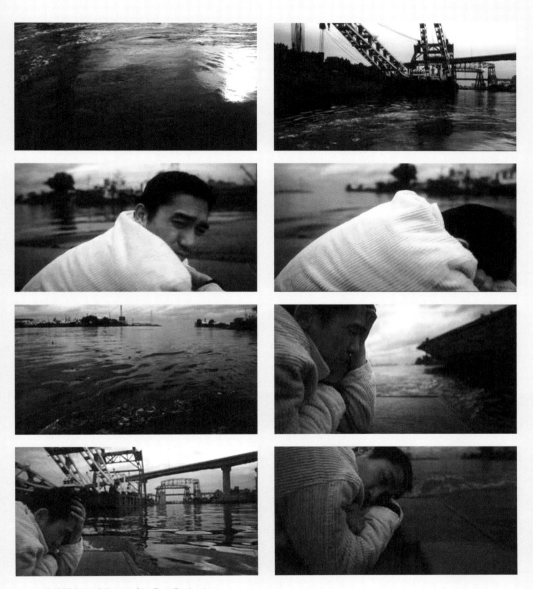

Images © 1997 Block 2 Pictures/Jet Tone Productions

GENDER AND CLASS SINCE THE 1980S

Text by
CAROLINA
ROCHA

ON THE SILVER SCREEN, Buenos Aires, as a film location, has witnessed and served as the setting for profound socio-economic and political changes in the last 45 years. During the early years of re-democratization, the city appeared subject to the sociopolitical forces that dominated national life. Films such as *Last Days of the Victim/ Los Últimos días de la víctima* (Adolfo Aristarain, 1982) and *The Official Story/La historia oficial* (Luis Puenzo, 1984) were shot on location. The first one follows a sniper hired by the manager of a corporation to stalk and kill his financial rivals. The impersonal backdrop of a major metropolis conceals the sniper's criminal activities as he moves through different neighbourhoods and easily accesses well-located apartments and humble dwellings. *The Official Story* was also shot in several locations: a public high school, Ezeiza, several bars, a public hospital, the Plaza de Mayo and the nearby Ministry buildings. The city is now the stage on which various political opponents act during the transition to democracy, and the relatives of the disappeared demand an explanation for their missing loved ones at the heart of the nation – the Plaza de Mayo.

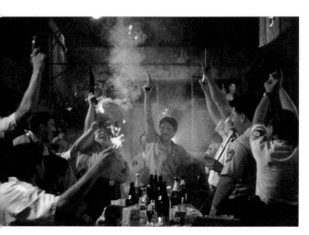

Male characters lose the traditional power they held in the last decade, signalling important transformations in gender relations.

The themes of economic crisis and criminality are also central to films produced in the 1990s, as male characters resort to illegal activities as a means of survival. From blockbusters such as *Wild Horses/Caballos salvajes* (Marcelo Piñeyro 1995) – in which pedestrians in the financial district ignore a distressed elderly man who attempts to take a hostage in his effort to recuperate his confiscated savings – to more experimental films such as *Pizza, Beer, and Cigarettes/Pizza, birra, faso* (Adrián Caetano and Bruno Stagnaro, 1998), which depicts the aimless lives of a group of adolescents and young adults who resort to petty crimes against the background of key cultural landmarks – to the immensely popular *Nine Queens/Nueve reinas* (Fabián Bielinsky, 2000), in which two partners in crime wander around Buenos Aires – men are no longer seen as respectable *pater familias*. They are now seen inhabiting the cutthroat environment of the metropolis.

As part of globalization, neo-liberalism privileges market forces, and divides men into losers and winners according to their economic and social status. Films produced after the economic crisis of 2001 often focus on men who lose their hard-won positions and are forced to start from scratch. A case in point is business owner Rafael (Ricardo Darín) in *The Son of the Bride/El hijo de la novia* (Juan José Campanella, 2001), who is forced to sell the restaurant that he inherited from his father to an international corporation when its management proves to be too taxing due to the economic fluctuations. Once the restaurant, which catered to middle- and upper-class patrons, is sold, Rafael buys a much more modest business in the same neighbourhood. While he has regressed financially, he is one of the few male characters who is not defeated

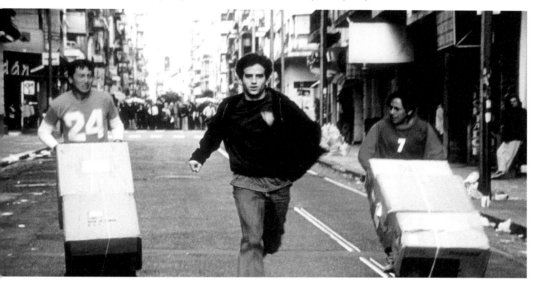

thanks to his prioritizing of family ties and friendship. By switching his attention to those whom he cares about, he is able to minimize the cost of his financial decline. Family as a micro-community that deflects loss is also a central topic in *El bonaerense* (Pablo Trapero, 2002). El Zapa (Jorge Román), a dark-skinned 30-year-old whose naivety lands him in trouble when he is arrested for cracking a safe, is rescued by his uncle and sent to La Matanza, a working-class district surrounding Buenos Aires, to join the police force. There slow-witted Zapa is recruited to collect bribes, but when he tries to do a dirty job on the side, he is framed by his superior and shot in the leg. Disgusted by the corruption, he leaves the peripheral areas of Buenos Aires and returns to the idyllic life of the provinces.

An unforgiving metropolis in a global world, Buenos Aires is depicted as a city that attracts many, repels some, and also becomes a place of encounters for lonely characters. *Bolivia* (Adrián Caetano, 2001) captures the discrimination that new immigrants from neighbouring countries face as they try to enter the labour force, competing and sometimes displacing native Argentines. *Lost Embrace/El abrazo partido* (Daniel Burman,

The themes of economic crisis and criminality are central to films produced in the 1990s, as male characters resort to illegal activities as a means of survival.

2004), shot in the Jewish neighbourhood of Once, emphasizes the diversity of its location, showing descendants of Eastern European Jewish immigrants alongside Italians and Koreans. University drop-out Ariel Makarov (Daniel Hendler) dreams of moving to Poland, retracing his grandparents' diasporic journey, but the tight-knit environment in which he lives conspires against his desire to relocate to new lands. If *Lost Embrace* represents the 'blessing' of having a caring family, in *Sidewalls/Medianeras* (Gustavo Taretto, 2011) the city and its unplanned development prove too much for the young characters who lead lives constrained by the divisive, artificial boundaries of urban life.

In the last four and a half decades, Buenos Aires has been the setting of important political and socio-economic transformations. As a location for impunity and justice, films of the early 1980s used the city to depict the still open wounds of the most recent military government, as well as to chronicle the diminishing socio-economic power of middle-class men. The trend of portraying this emasculation as a consequence of Argentina adopting neo-liberalism and its concomitant reform of the welfare state has continued throughout the 1990s. More recent films oscillate between denouncing the city as an oppressive force on those lacking networks of family or friends, and presenting it as a site of redemption. ✢

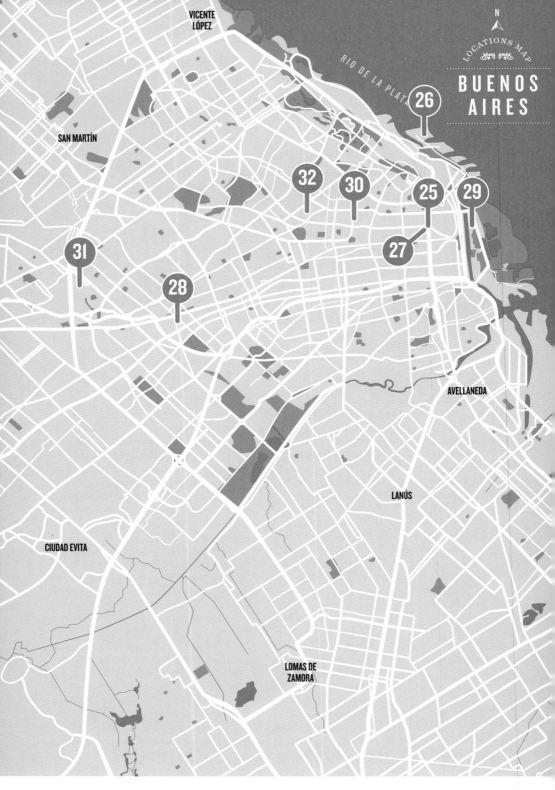

BUENOS AIRES LOCATIONS

SCENES 25-32

maps are only to be taken as approximates

PIZZA, BEER, AND CIGARETTES/
PIZZA, BIRRA, FASO (1998)

Obelisco, Av. 9 de Julio and Av. Corrientes

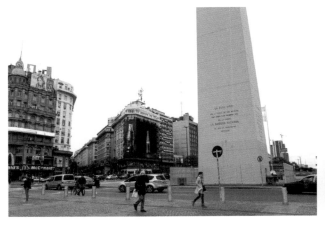

FEW FILMS ARE MORE representative of New Argentine Cinema than *Pizza, Beer, and Cigarettes*. Caetano and Stagnaro's tour de force, which follows the truncated and violent misadventures of a group of petty thieves, is a powerful testimony to the decay of Argentine society in the neo-liberal 1990s. *Pizza, Beer, and Cigarettes* traces a journey across a ravaged Buenos Aires, and the city is a dark presence throughout. Thirteen minutes into the action this darkness achieves an explicit embodiment in a scene that shows the characters interacting with the Obelisco, the most renowned of *porteño* (of Buenos Aires) icons, standing in the middle of the Av. 9 de Julio. After observing it and discussing its phallic powers for a while, the characters jump the fence and break into it. Inside, an empty and decadent space waits. Cluttered with the remnants of half-visible political graffiti, pornographic magazines and tetra-pack wine, the Obelisco, devoid of its monumental powers, finds our anti-heroes insulting and groping each other all the way to the top. Once there a dialogue ensues about the impossibility of seeing anything from these heights. And indeed, beyond some blurry city lights, all that is visible is a bird's-eye view of the police arresting one of the members of the group who was left behind. The Obelisco thus turns itself into a dark and defective vertical panopticon that offers an omen that these boys will not heed. ↝*Fernando Sdrigotti*

Directed by Adrián Caetano and Bruno Stagnaro
Scene description: The characters break into the obelisco
Timecode for scene: 0:13:00 – 0:17:02

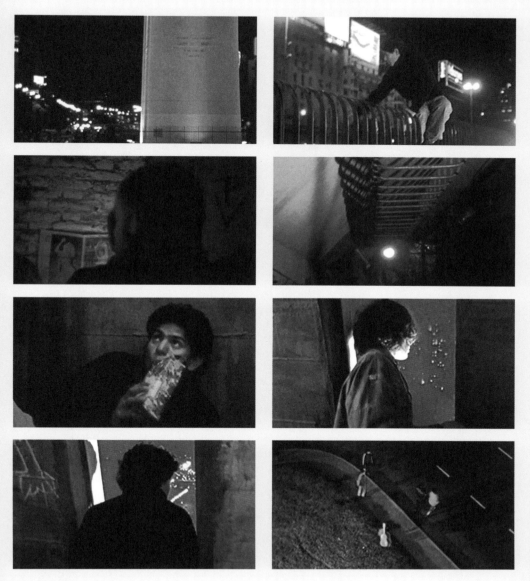

Images © 1998 Palo y la Bolsa Cine/INCAA

THE SLEEPWALKER/LA SONÁMBULA (1998)

A dystopian collage prominently featuring
the Usina Puerto Nuevo building in the Buenos Aires port

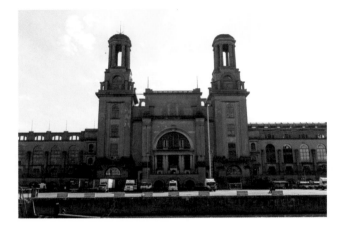

THE SLEEPWALKER takes place in 2010 (the near future at the time of the
film's release in 1998). The film proposes a dystopian future: an environmental
catastrophe has devastated the country and a repressive government is in
power. Moreover, an industrial accident produced toxic gasses that wiped the
memories of 300,000 people (ten times the number of victims of the military
dictatorship of 1976–83). To create the sense of estrangement that is typical of
the genre, Spiner deliberately avoids portraying a recognizable Buenos Aires.
Instead, the audience is prompted to identify it through isolated shots of the
Abasto Market or the Usina Puerto Nuevo building in the city's port. Most
conspicuously, a fantastic collage of real and artificial imagery suggests that
a vast and complex network of elevated motorways has been constructed.
The protagonist, Eva (Sofía Viruboff), is one of the victims of the accident. In
the opening sequence she is forced into an unmarked police car and a series
of shots show the car travelling through the web of highways. The scene
alludes to the kidnapping of dissidents under the military junta. While the
highways might reference the sci-fi classic *Metropolis* (Fritz Lang, 1927), they
could also allude to the dictatorship, during which the mayor of Buenos Aires,
Osvaldo Cacciatore, planned a drastic redevelopment of the city through the
construction of highways. With the collapse of the regime, his plan was never
completed. Perhaps *The Sleepwalker* shows what Buenos Aires would have
looked like in 2010 had the dictatorship never ended. **Mariano Paz**

Directed by Fernando Spiner
Scene description: Eva is captured by the security forces of a totalitarian government
Timecode for scene: 0:05:30 – 0:07:06

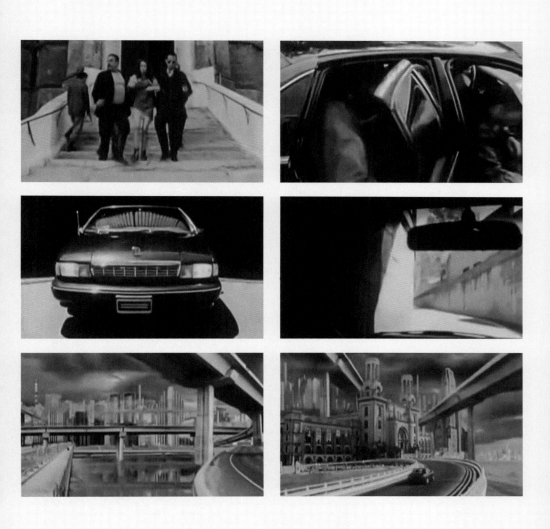

TANGO (1998)

Confitería Ideal, Suipacha 384

CARLOS SAURA'S *Tango* is a film about the making of an elaborate tango show, but the lines between these layers of fiction and performance are constantly blurred. The majority of the film takes place in a vast rehearsal space (or perhaps it is the final performance space), which is strongly lit with bright solid colours that often throw the dancers into silhouette. It is modernist and minimal, a staging ground for Mario (Miguel Angel Solá), the show's director, to play out his fascinations, fantasies and traumas. In direct contrast with this location, however, is an early scene in the Confitería Ideal bar and tango club. This is a proud and extremely well-preserved remnant of the heyday of Argentine tango, at least as it exists in the public imaginary. It is here, in this temple of old school tango and 1920s style, that we see the traditional roots of Mario's show. The floor clears and Carlos (Juan Carlos Copes), the show's aging choreographer, is invited to give a masterclass in restrained and elegant technique. He chooses a delighted partner from the audience, and together they move slowly and confidently up and down the floor, allowing the camera to take in the atmospheric surroundings. It is also here that the old school gangster, who owns 50 per cent of the show, presses Mario to give his *moll* an audition, an action that will set the rest of the drama in motion. ✦*Michael Pigott*

Directed by Carlos Saura
Scene description: The tango masterclass
Timecode for scene: 0:16:00 – 0:24:50

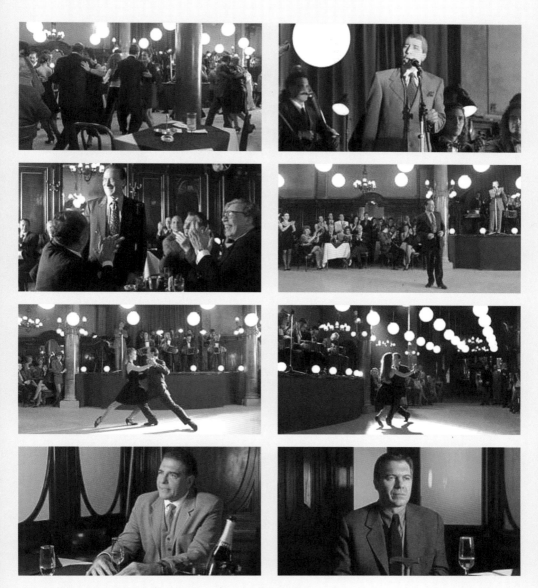

GARAGE OLIMPO (1999)

*El Olimpo detention centre
(between Olivera, Lacarra and Ramón Falcón Streets)*

GARAGE OLIMPO'S main location, naturally, is the once clandestine detention centre of El Olimpo (in the middle of Vélez Sarsfield District, next to Av. Rivadavia), where torture and extermination were carried out for six months between 1978 and 1979 during the last dictatorship. With capacity for 150 people, a total of 500 *detenidos/desaparecidos* (detainees/disappeared) are believed to have been tortured there. In the film, the focus is arguably as much on the clandestine military activities (including kidnapping of victims), as on the protagonist, prisoner María (Antonella Costa), and her love–hate relationship with her torturer Félix (Carlos Echevarría). The very last sequence in the Olimpo garage works as a meaningful synthesis. María's fate – as she returns with Félix from a clandestine stroll through the city – is revealed as no different from that of the others. Through what was called *vuelos de la muerte* (death flights) the military disposed of naked prisoners into the Río de la Plata and the Atlantic. To avoid resistance, they tricked prisoners into believing they were getting a vaccine before transferral to a common prison to await their trial. We see here how, in fact, they are drugged (injected with pentothal) and put into trucks. Several aerial images of Buenos Aires have presciently suggested this outcome. By the end of the sequence we see the trucks moving out, as the image of the Olimpo, now empty, dissolves into that of a C-130 Hercules flying over the river, while Héctor Panizza's 'Aurora' (1908) (a hymn to the Argentine national flag) plays on the soundtrack.
⇢Santiago Oyarzabal

Photos © main picture: Adam Jones (wikipedia) / detail: Sking (wikipedia)

Directed by Marco Bechis
Scene description: María's fate is revealed
Timecode for scene: 1:31:06 – 1:34:25

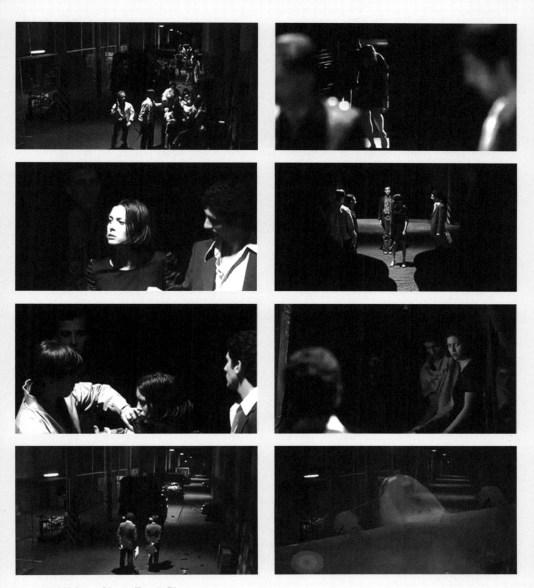

Images © 1999 Classic/Nisarga/Paradis Films

NINE QUEENS/NUEVE REINAS (2000)

Puerto Madero

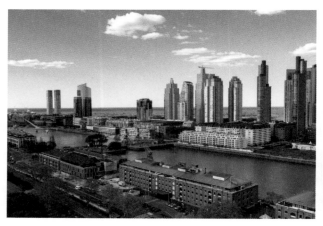

WHILE JUAN (Gastón Pauls) and Marcos (Ricardo Darín) celebrate a shady deal selling the eponymous 'Nine Queens', a valuable collection of stamps, the briefcase containing them is snatched from the unsuspecting con men's grip by a passing *motochorros* (motorcycle bandits). As they give chase, the unmistakable backdrop of Puerto Madero comes into view. This recently regenerated waterfront is reminiscent of any global city, yet distinctive local features ensure that the film's backdrop cannot be mistaken, and few places can better capture the rapid economic modernization of 1990s Argentina. However, as emphasized by the juxtaposition of the speeding *motochorros* with Puerto Madero's smart walkways, even this symbol of modernity cannot mask or escape the corruption that plagued the country at that time. In slow motion, the camera follows the stamps as they are tossed into the air by the thieves and come to rest in the river. The camera cuts to the saturated stamps, and the distraught figures of Juan and Marcos. In a matter of seconds, everything is lost. The fate of the Nine Queens not only prefigures the film's tense ending, when the cheque used to purchase the stamps is rendered worthless by the bank's foreclosure, but also seems to foreshadow Argentina's dramatic fall from 'poster child' of neo-liberalism to economic ruin in 2001, a year after the film's release. Meanwhile, Puerto Madero stands as a monument to a time of excess and superficial prosperity before all that appeared solid melted into air. **⊷Cara Levey**

Directed by Fabián Bielinsky

Scene description: Marcos and Juan are robbed outside of the Hilton

Timecode for scene: 1:05:29 – 1:06:35

Images © 2000 Patagonik

FELICIDADES (2000)

LOCATION *A flat just off Guardia Vieja Street, in the background is Abasto Shopping Centre*

FELICIDADES IS A REMARKABLE dark comedy that narrates several stories that intersect on Christmas Eve, one of the most significant dates in the Argentine festive calendar. The night of December 24 is a date for family reunion and celebration; it can also be a date for loneliness and sadness. It is this latter type of Christmas Eve that *Felicidades* takes as its setting. In typical New Argentine Cinema fashion the film manages to collaterally capture the decadence of the late 1990s/early 2000s. Homelessness, corruption, loneliness and urban squalor are all frequent presences in the film. A particularly pathetic scene might illustrate what I am hinting at here. Rodolfo (Pablo Cedrón) is pursuing Laura (Silke), trying to chat her up, when he bumps into Héctor (Marcelo Mazzarello), a disabled man. He helps Héctor make it to his building, and once there learns that the lift is broken; he ends up carrying him five stories up the stairs. Once in the flat he tries to leave but Héctor keeps him engaged in conversation. Héctor's flat is a rotten affair where nothing seems to work: his drinks are flat, his fridge half empty, the toilet is dirty, the lights do not work very well and everything smells foul. The cherry on top of the pie is a colony of bats that have found shelter behind his blinds, defecating and stinking up the place further. Now Héctor is condemned to living a life of closed windows, surrounded by faeces and putrefaction. A perfect metaphor for life in neo-liberal Buenos Aires. **↝Fernando Sdrigotti**

Directed by Lucho Bender

Scene description: Rodolfo's failed pursuit of Laura takes him to Héctor's stinky flat

Timecode for scene: 0:23:38 – 0:47.44

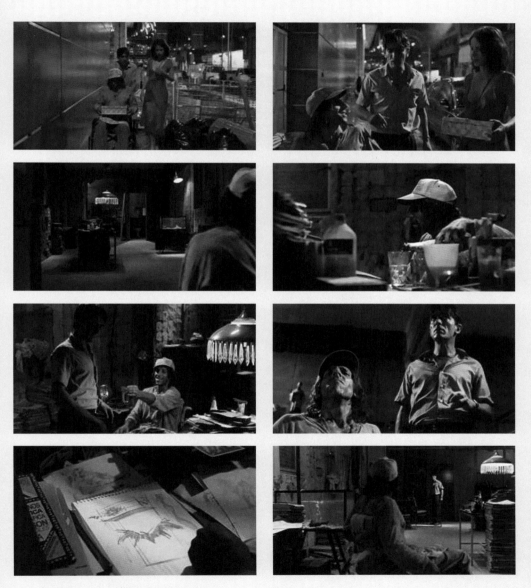

Images © 2000 Bendercine/Tango Films S.A.

THE SON OF THE BRIDE/EL HIJO DE LA NOVIA (2001)

Cafetería Buenos Aires, corner of Gallardo and Nogoyá Streets

WE SEE A TYPICAL *café de barrio* (neighbourhood cafe) of the mid-twentieth century, with a metal awning that maintains its original, antique aspect. This is a place of daily rituals and routines of neighbourhood sociability, which seems to offer a journey back in time. This is the venue for the 'wedding' party of Rafael Belvedere's (Ricardo Darín) parents, Nino (Héctor Alterio) and Norma (Norma Aleandro), the latter of whom suffers from Alzheimer's disease. Although located at the intersection of Gallardo and Nogoyá Streets in the neighbourhood of Versalles, in the film the *cafetería* is opposite the Belvedere family restaurant. It has been purchased by Rafael after he sold the restaurant. The crossing of the street in this scene, from restaurant to *cafetería*, accompanies the character's deep change of perspective. With autobiographical notes – Campanella's mother suffered from Alzheimer's and his biological father wanted to marry her – the film offers a social and generational portrait of Argentina at the turn of the century. We see a generation and social class marked by obsessive dedication to work and neglect of affection. We see also a personal crisis, Rafael's, in dialogue with the economic and political turmoil that would result in president Fernando De la Rúa's resignation in December 2001. The party in the *cafetería* symbolizes the potential for a re-constructed life. **↦ Ana Silva**

Directed by Juan José Campanella
Scene description: *The wedding party*
Timecode for scene: 1:48:56 – 1:53:56

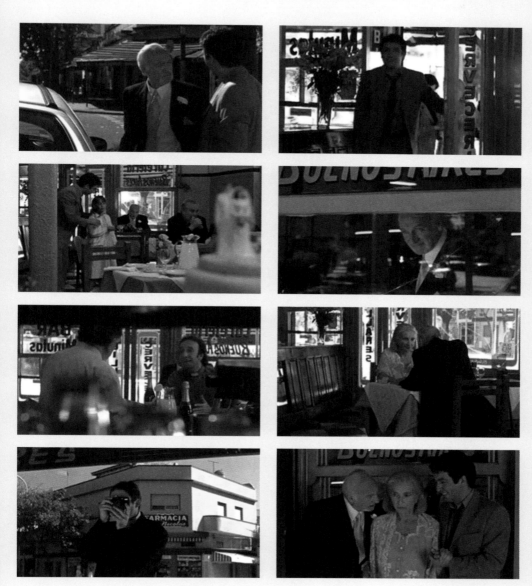

BOLIVIA (2001)

Corner of Lavalleja Street and Loyola Street

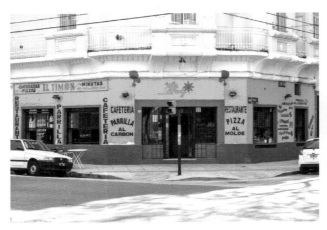

BOLIVIA PAYS HOMAGE to the very *porteño* (of Buenos Aires) culture of the corner cafe to a degree rarely seen in other Argentine films. Set almost entirely within the four walls of a *parrilla* bar, the film works as a synecdoche for the city and all its intercultural and social interactions. Except for a handful of scenes, the spectator encounters the complex web of relations amongst the characters through the action and dialogue taking place within this confined, claustrophobic space, where all elements come together to complete a profoundly symbolic representation of pre-2001 Buenos Aires as an intense, multicultural, conflicted, code-loaded city. From the first image, the director, Adrián Caetano, makes it apparent that the action and meaning of *Bolivia* will turn upon the place of stereotypes in society. The opening scene is a set of snapshots of the *parrilla* and its iconic details: a photo of Carlos Gardel, a football club pennant, a young Maradona, unwrapped toothpicks, almost transparent paper napkins, a handwritten sign advertising the 1-peso *choripan* (chorizo hot dog). The scene ends with what will become a leitmotif in the film: the outer facade of the *parrilla* bar. Crucially, at this moment, we see another icon of the capital city: a black-and-yellow taxi, recognizable even in the black-and-white stock. One by one, in an urban-western style, the protagonists will begin to pass through the doors to tell their tales of life in the city. **⚬→Carolina Orloff**

Directed by Adrián Caetano
Scene description: An introduction to the parilla (grill)
Timecode for scene: 0:00:21 – 0:01:29

Images © 2001 Iacam/La Expresión del Deseo

THE FANTASTIC AND FUTURISTIC CITY

Text by
JOANNA
PAGE

IN SCIENCE FICTION AND FANTASY films, the city is rebuilt in an unfamiliar time or space. A few iconic landmarks usually remain to throw into relief the cityscape's expansion, distortion, recreation or even destruction. In many cases the estranging effect of the city's reconfigured architecture prepares us for universal themes, such as the dehumanizing experience of modernization or the authoritarian abuse of technologies of control. On the other hand, these fabrications and falsifications often capture what is unique about a city: its own mode of being in time and space, its specific coordinates within a global system of trade and traffic.

Incursions into the science fiction genre have been relatively rare in Argentine cinema. High-budget special effects, a hallmark of the genre in Hollywood or Europe, are often beyond the reach of local film-makers. There is also the difficulty of imagining Argentina, with its chronic underfunding of scientific research, at the spearhead of intergalactic missions. For these reasons, Argentine futuristic and fantasy films have tended towards one of two approaches (or, indeed, both): the metaphysical and the parodic/reflexive.

In the first case, they draw on the cerebral concerns of the nation's rich heritage in fantastic

literature. The script of *Invasion/Invasión* (Hugo Santiago, 1969) was penned by Borges and Bioy Casares, writers who revelled in paradoxes of time and space. *Invasion* is set in Aquilea, a city that is, and is not, Buenos Aires. The map in Don Porfirio's (Juan Carlos Paz) apartment traces a recognizable outline, but the film shies away from familiar landmarks and reorganizes the city's geography, keeping the docks to the south and the delta to the north-east, but inventing a range of mountains to the north-west. Shot in black-and-white, *Invasion* also refuses to settle within a single time frame: it is ostensibly set in 1957, but includes car models from the 1960s and makes use of noir and expressionist styles harking back to the 1930s. The film's disconcerting play with time and space lends its themes of invasion and resistance a universal quality, and has left it open to allegorical readings of many kinds.

Moebius (Gustavo Mosquera, 1996) is also a distinctly Borgesian fable, and a prime example of a sci-fi film that makes a virtue of its very low budget. Heading underground into Buenos Aires's *subte* (subway), the film narrates the mystery of a disappearing train, a puzzle that requires no expensive special effects. The metro system, it is discovered, has become so complex that it has transformed into a Möbius strip, twisting over itself and taking the train into another dimension, from which there is no exit. Again, the film has invited allegorical interpretations linking it to the disappearance of thousands of citizens under the military regime of 1976–83.

Parallel universes leave us with unsolved conundrums in Spiner's retrofuturistic vision of Buenos Aires in *The Sleepwalker/La sonámbula* (Fernando Spiner, 1998). The city's fabricated skyline is a deliberately unrealistic mock-up, given a grayscale, two-dimensional effect. The vertical city, criss-crossed with multi-level expressways, consciously cites *Metropolis* (Fritz Lang, 1927) and *Blade Runner* (Ridley Scott, 1982). Unlike these

obviously simulated images, many of the film's most fantastical sequences are actually shot in real locations in the city and province of Buenos Aires. The film's protagonist, Kluge (Eusebio Poncela), passes the corroding frames of boats that for years remained strewn along the old docks in La Boca, left to rust when the city's business moved to new dockyards in the north. The phantasmagoric landscape he and Eva travel through on their flight from the city, of tree skeletons and ruined houses emerging from water, was in fact shot in the real town of Epecuén, left abandoned after a catastrophic flood in 1985. It is as if the fabric of the futuristic Buenos Aires is continually punctured by the failures of modernization and state neglect, strewn with the refuse of abandoned projects and obsolete technology.

A more thoroughly futuristic vision of Buenos Aires is offered in the 3D animation film *Condor Crux, the Legend/Cóndor Crux, la leyenda del futuro* (Juan Pablo Buscarini, Swan Glecer and Pablo Holcer, 2000), but again it is one built precariously on a repressed past. An early shot of the Obelisco from an airborn police patrol unit as it flies down the Avenida 9 de Julio establishes 'Darwin City' as a future Buenos Aires. The city is an artificial bubble, severed from the continent's indigenous roots. The Gloria Mundi Corporation – a caricature of the powerful multinationals that gained monopolies under Menem's unchecked neo-liberalism – controls all

Many Argentine science fiction films exploit the ironies of setting a quintessentially First World genre in a more unevenly developed Buenos Aires.

media and satellite transmissions. The banished hero Cóndor Crux eventually liberates the city from the grip of its evil dictator, and reintegrates it with traditional, rural and indigenous Latin America. At the end of the film, a new Darwin City replaces the perpetual night, artificiality and geometric architecture of the old one with sunlight, greenery and curves. In a final gesture of regional integration – and utter disrespect for the laws of natural habitats – an Andean condor flies majestically across the cityscape as it recedes from our view.

Many Argentine science fiction films exploit the ironies of setting a quintessentially First World genre in a more unevenly developed Buenos Aires. The reflexive and playful *Stars/Estrellas* (Federico León and Marcos Martínez, 2007) documents the making of a science fiction film in a Buenos Aires shantytown. A triumph of creative recycling, the spacecraft used in the film is assembled from a miscellany of unwanted junk: the body of an old Citroën, bicycle handlebars and a floor-polisher attached to the side to simulate a fulminating weapon of attack. The film's (mis)appropriations of the science fiction genre remain ironic and unconvincing: the motley crowd of shantytown dwellers are implausibly elevated to the front line of the nation's defence, and the aliens are not vanquished by sophisticated technology, but by the shantytown's dirty water and slime, which causes them to melt. Like *Stars*, many futuristic and fantasy films set in Buenos Aires – a city largely made up of European immigrants, located at the periphery of the modernized world – point to the city's particular experience of modernity as a chaotic process of spectacular leaps, gross inequality, economic volatility and state negligence. �֍

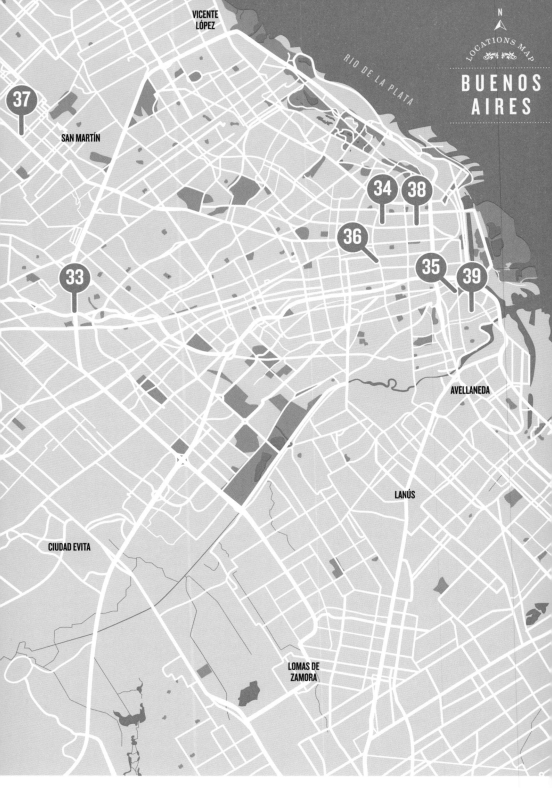

N

RIO DE LA PLATA

VICENTE
LÓPEZ

37

SAN MARTÍN

34 38

36

33

35 39

AVELLANEDA

LANÚS

CIUDAD EVITA

LOMAS DE
ZAMORA

BUENOS AIRES LOCATIONS

SCENES 33-39

maps are only to be taken as approximates

EL BONAERENSE (2002)

LOCATION *Av. General Paz, near Acceso Oeste*

TRAPERO'S FILM explores corruption within the police. The protagonist, Zapa (Jorge Román), a locksmith and petty criminal, secures a place as a new police recruit thanks to his uncle's contacts. Not long after arriving in Buenos Aires, Zapa is awoken on a park bench by the noise of traffic, a sound that repeatedly punctuates the film. The sense of Zapa's alienation and the image of the city as a chaotic, corrupt, hostile environment is captured in this early scene. He is seen lying beneath a blurred neon sign and, as the shot pans round towards the road, we see litter strewn on the path and a man selling flowers to passing drivers, hinting at crisis and deprivation. Zapa stops to chat to police in a patrol car on a road lined with buses, before crossing train tracks, and encountering a protest: a juxtaposition highlighting the differences between those living within and those outside the corrupt system. The sideways movements of his head and the sense that he could easily become swept up by the protest reinforce his own liminal position. He walks up a pedestrian ramp where the tattered posters and various road signs pointing in different directions signal the degradation and potential that the city holds. The action unfolds around Av. General Paz, the motorway surrounding Buenos Aires, which serves as a constant reminder of the ways in which Zapa is sucked into the frenetic pace and corruption of city life. **•→Eamon McCarthy**

Directed by Pablo Trapero
Scene description: Zapa awakes in Buenos Aires
Timecode for scene: 0:16:26 – 0:17:28

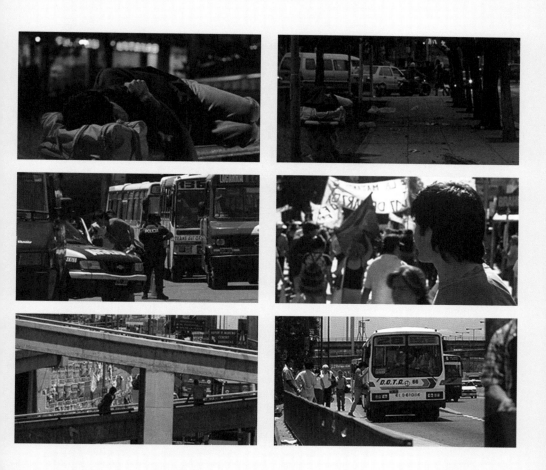

LOST EMBRACE/EL ABRAZO PARTIDO (2004)

LOCATION *Shopping mall in Once, on Lavalle Street between Larrea and Azcuénaga Streets*

LOST EMBRACE begins with a first person voice-over narration while a handheld camera follows a male character around a location that an intertitle describes as 'La Galería'. His face is not completely framed until the narrator reveals himself as Ariel Makaroff (Daniel Hendler), the protagonist of the story. He presents himself as one of the workers in a shopping mall in the district of Balvanera in Buenos Aires, also known as Once, through the use of 'we'. He says, 'to customers, we're just salespeople, who disappear when the stores close.' During this opening sequence, there are several cutaways to point-of-view shots as he walks through the mall, corresponding to his narration. The use of the zoom lens establishes another, more objective point-of-view through which the spectator views the interactions between the inhabitants of the shopping mall. The zooming movement towards and away from the characters at work in the shopping mall presents an objective view of the sellers and their business, whilst subjecting them to Ariel's perception. This strategy emphasizes the first person narrator's sense of detachment, which allows him to make ironic comments about the community, to which he belongs. Therefore, the sequence establishes Ariel as simultaneously a member and observer of Once, which allows him to articulate notions of belonging to the diasporic community with an ironic detachment, thereby introducing the comic tone of the film. **Natália Pinazza**

Directed by Daniel Burman
Scene description: A walking introduction to 'La Galería'
Timecode for scene: 00:00:28 – 00:02:40

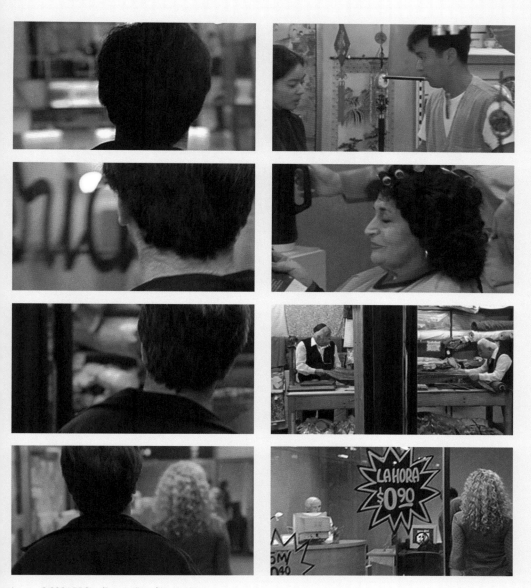

THE MOTORCYCLE DIARIES/
DIARIOS DE MOTOCICLETA (2004)

LOCATION > *Av. Caseros between Bolívar and Defensa*

IN THE MOTORCYCLE DIARIES, Buenos Aires is merely the starting point
for a voyage of adventure, romance and self-discovery, as Ernesto 'Fuser'
Guevara (Gael García Bernal) and his friend Alberto 'Mial' Granado (Rodrigo
de la Serna) set off across South America in 1952. For a film so concerned
with geography, journeys and transformations, Buenos Aires holds particular
significance: the city represents the safe, familiar place where these two
figures grew up and attended university. While the film later captures the
rich, varied and overwhelming beauty of the Latin American continent,
meandering through Chile, Peru and Colombia to the Guajira Peninsula
in Venezuela, it begins with the intimacy of family and friendship. But
Buenos Aires must be left behind in order to encounter cultures, people
and customs alien to their own, thus challenging their youthful notions and
preconceptions of life. Having loaded up Alberto's dog-eared Norton 500
motorcycle, *La Poderosa* ('The Mighty One'), they say farewell to Ernesto's
doting family on Av. Caseros. Alberto assures Ernesto's dad (Jean Pierre
Noher) that his son is 'in good wheels, don't worry'; nevertheless, the father
surreptitiously hands his son a pistol, just in case. Embraced by his mother
(Mercedes Morán), Ernesto is reminded to write home and take his asthma
medicine, highlighting both his youthful *naïveté* and physical fragility. Upon
departing, their overburdened bike almost collides with an oncoming bus, but
Alberto swerves and they narrowly avert an immediate demise. This occasion
marks the first of many perilous, eye-opening and transformative encounters
on their journey of a lifetime. **↦ Adam Gallimore**

Directed by Walter Salles
Scene description: Ernesto and Alberto depart for their journey across South America
Timecode for scene: 0:03:46 – 0:06:33

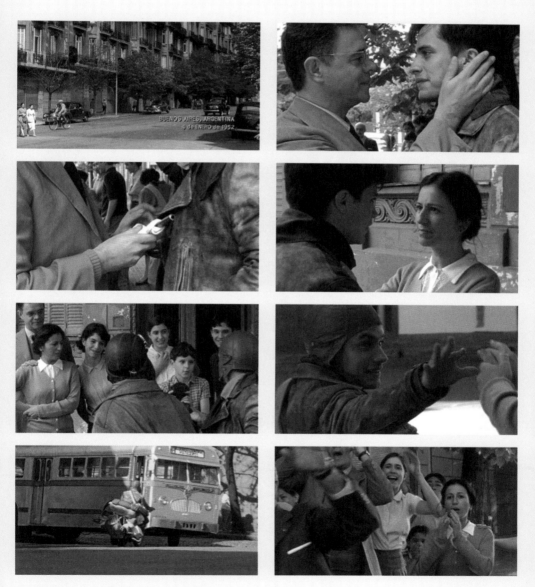

Images © 2004 BD Cine/FilmFour/Tu Vas Voir Productions

THE TAKE (2004)

LOCATION *Av. Jujuy and Av. Independencia, Balvanera*

THE SCENE BEGINS with several workers and hundreds of left activists in front of Brukman, one of the more than 200 factories taken over during the crisis of 2001. The police have just violently evicted them from the factory to protect the bankrupt owners' and bankers' interests. Soon we see rubber bullets and tear gas being employed against fleeing protestors, a group that includes the film-makers who are clearly on the side of those protesting. Confrontation and labour resistance is not alien to the city of Buenos Aires, whether in this open form of struggle or in many other more subtle, everyday ways. The film tells the story of the Forja, Brukman and Zanon factories, which represent the many takeovers that occurred against the backdrop of the presidential election of 2003, while an International Monetary Fund mission suggested yet another austerity plan. The desperate situation of those facing unemployment (25 per cent of the national population were jobless at the time) due to mismanagement or fraudulent financial operations, forced a series of workplace clashes during this turbulent period. The economic breakdown leads the workers to 'occupy, resist, produce' as a way of defending their only chance of making a living. In so doing they experience a difficult but inspiring process of learning and teaching how to create something new out of crisis, how to produce without a boss or a foreman, and how to democratically determine their own fates. **↝Juan Grigera**

Directed by Naomi Klein and Avi Lewis
Scene description: The workers resist being dislodged from the Brukman textile factory
Timecode for scene: 1:11:46 – 1:14:57

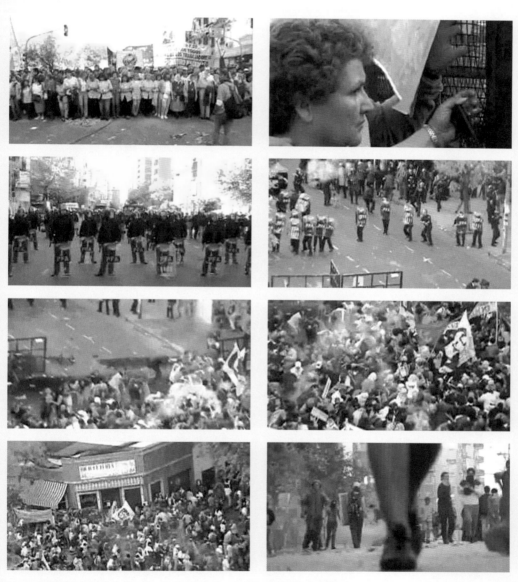

Images © 2004 Klein Lewis Productions/National Film Board of Canada/Barna-Alper Productions

BLESSED BY FIRE/
ILUMINADOS POR EL FUEGO (2005)

Hospital Interzonal General de Agudos Eva Perón, Ricardo Balbín 3200, General San Martín District

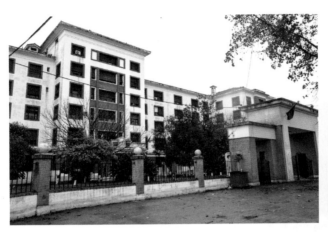

IN THE MIDDLE of the night an ambulance moves through the streets of Buenos Aires, toward the emergency services of a public hospital. A survivor of the Malvinas War, in a situation of despair and abandonment, has decided to end his life. The streets could be any, and the hospital too, though the sequence was shot in the Hospital Interzonal General de Agudos Eva Perón, in General San Martín. Ex-combatant Vargas (Pablo Riva) enters the Emergency wing and is later taken to a ward containing all the clichés of Third Worldist, guilty sanitarism: walls tiled up to the ceiling, equipment so aged that it does more damage than good; exhibiting the cruel signs of abandonment in his own body, already mutilated during the war. Greyish-white walls and greasy surgical instruments portend an unhealthy, perhaps deadly fate. The sequence is minimal, but enough to make the protagonist, middle-class journalist Esteban (Gastón Pauls), feel the weight of history that united and separated him from Vargas during those 74 days in 1982, as well as during the pre- and the post-war periods. Public hospitals during the post-dictatorship continue the war by other means – night in the ward resembles too closely the nights of the conflict, with its urgencies and violence. The film's pretentious sanitarism cloaks with certainties the ex-combatants' angst for a future that will not be blessed by fire. *Blessed by Fire* is a fiction which does not hide its own miseries. One day there may be honours for the young who wish to return home after war, and manage to do so. In the meanwhile, we have to witness these stories that tell us only of their own guilt, treasons and ill locations. ➻*Carlos Giordano*

Photo © Marcelo Sarbia

Directed by Tristán Bauer
Scene description: Vargas is brought to the hospital
Timecode for scene: 0:02:17 – 0:05:54

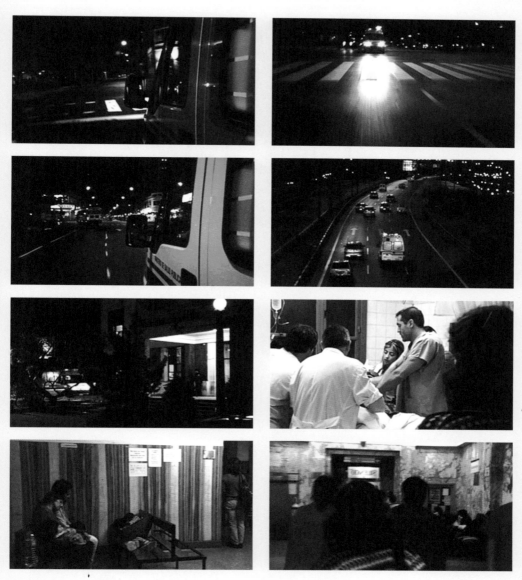

FANTASMA (2006)

Teatro General San Martín, Av. Corrientes 1530

ARGENTINO VARGAS, the actor who played the protagonist of Lisandro Alonso's previous film, *Los muertos* (2004), wanders disinterestedly through the foyer of the Teatro San Martín, the prestigious arts centre in the middle of downtown Buenos Aires. Vargas inhabits the space as a spectre, a flesh and blood ghost from another movie. *Los muertos* is playing in the Teatro's cinema, and the actor is ostensibly there for a screening, but this self-reflexively meta-fictional film places him as an emblematic manifestation of the uneasy meeting of characters, locations and stories from Argentina's wild interior, with the cosmopolitan everyday of the capital. Vargas roams the empty hulk of the San Martín, with its wide open foyers, sharp lines and modernist styling, half-heartedly exploring its unusually quiet spaces. In the selected sequence he moves from the first floor down to the main foyer. Both spaces have floor-to-ceiling glass windows that look out onto Av. Corrientes. His attention falls on a poster for *Los muertos* within a glass display case, which prominently features a line-drawing of himself. Next, he slowly makes his way from one side of the space to the other, where a merchandise stall lies abandoned, many of its glass cabinets empty – another of the many images of glass boxes that are littered throughout the film. Vargas, as specimen, looks out at the street from inside the giant glass box that is the Teatro San Martín. The film image too, is a kind of travelling glass box. ◆*Michael Pigott*

Directed by Lisandro Alonso
Scene description: Looking out from the glass box.
Timecode for scene: 0:04:37 – 0:11:39

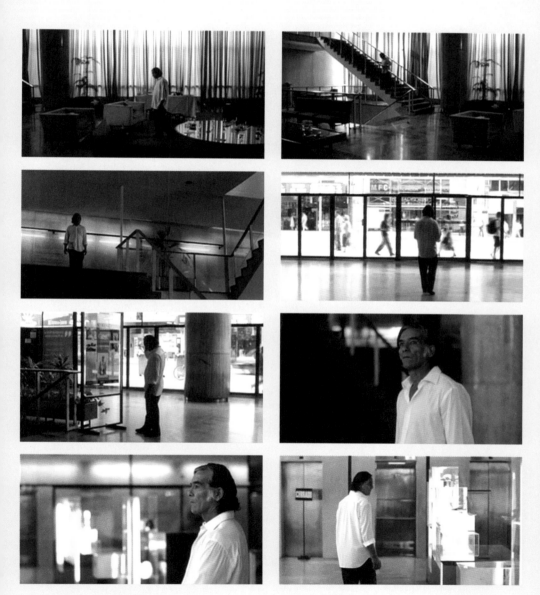

MARADONA BY KUSTURICA (2008)

La Bombonera (Boca Juniors' stadium), Brandsen 805, La Boca

THE PORTRAYAL of Buenos Aires in *Maradona by Kusturica* illustrates the director's biased admiration of one of the greatest and most controversial footballers of all time. Diego Armando Maradona scored his two most memorable goals against England, when he led Argentina to World Cup victory in Mexico in 1986. The Serbian director focuses on the player and the person: Maradona's humble origins and love for his family, drug addiction and heart problems, political stands, and celebrated catchphrases and stories. Accordingly, images of the city include the house in poverty-stricken Villa Fiorito where he was raised, and Estación Constitución on the day, in 2005, when he left for Mar del Plata to support the Latin American leaders when they refused to sign the ALCA agreement – the US-endorsed Free Trade Area of the Americas – despite pressure from then US president George Bush. Referred to by Kusturica as (the Mesopotamian god) Gilgamesh and as a Mexican revolutionary, Maradona was described by Eduardo Galeano as a 'god of mud, a sinner, the most human of all gods' (pp. 298-99). He inspires devotional feelings in a country where football is religion. Consequently, it is the scenes in his temple La Bombonera that show us the idol, the fan and the club united as one, a holy trinity. Throughout the film we have seen images of Diego playing here. In the selected sequence, during his testimonial game in 2001, Diego gives a speech where he apologizes for his mistakes, and asserts that football should not pay for them.
➡*Ramiro Montilla and Santiago Oyarzabal*

Directed by Emir Kusturica
Scene description: 'La pelota se mancha' ('The ball doesn't get dirty')
Timecode for scene: 1:24:43 – 1:25:01

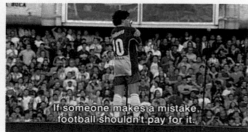

If someone makes a mistake, football shouldn't pay for it.

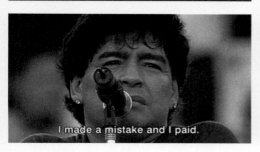

I made a mistake and I paid.

Images © 2008 Pentagrama Films/Telecinco Cinema/Wild Bunch

MARTÍN REJTMAN AND BUENOS AIRES

Text by
MARTÍN
REJTMAN

Internationally acclaimed director Martín Rejtman has been making films in Buenos Aires for thirty years. In an interview with the editors he offers some of his impressions of the city.

I WAS BORN in Buenos Aires in 1961 and have lived in several *barrios* (neighbourhoods): I spent my childhood in Caballito, later moved to Barrio Norte, Belgrano, and finally ended up opposite the zoo in Palermo, always with my parents. Upon my return from the United States, in 1988, I settled in Palermo Viejo. Distinguishing between the changes in the city and those I have undergone myself is not easy: was Buenos Aires less complex decades ago, or was my perspective more innocent?

Of course, in the 1980s I did not know Buenos Aires as well as I do now and was unable to grasp several things. My emotional baggage was also different. I have the impression that filming in the city was simpler back then. When we made *Doli Goes Home/Doli vuelve a casa* (1984) we shot a scene in a traditional (now closed) fast food restaurant, a ChéBurger, on Florida Street, and it was very easy. I entered and asked, they said 'yes' and we filmed. Three decades later we wanted to film in another fast food restaurant for *Two Gun Shots/Dos disparos* (2014), and despite talking to absolutely all the companies, we could not get a permit from them. In the end, we found the 'ruins' of the last of the Pumper Nics (a defunct fast food chain which used to compete with ChéBurger) in a shopping mall in Moreno, in Gran Buenos Aires. The logo was still on the door, and part of the burger menu remained. It felt like a nostalgic return; we brought tables and chairs and put the place together again.

Since the 1990s, with the arrival of the big corporations, everything about filming in the city has become more complicated, with legal permits, formal requests and the like. Also, the frequent crises in Argentina make film-making problematic because we are bound by the dollar rate defining the cost of the production. In *Rapado* (1992/1996) hyperinflation is very present, although by then the country had left it behind. Anyhow, I never intend for my films to show current events, and the feeling that another crisis will follow is unavoidable. When I wrote the script of *The Magic Gloves/Los guantes mágicos* (2003), during the convertibility system (when the Argentine peso was pegged to the US dollar), imports were commonplace, but by the time of filming, after the 2002 devaluation, the situation had changed radically. Some of the people who read the script at this point felt that the main anecdote in the story was outdated because the dollar was extremely expensive, and imports almost impossible. However, when the film actually came out the situation had changed again!

My films are mostly set in middle-class *barrios*, and some critics have interpreted them as depicting middle-class decadence. However, I feel I tend to choose locations that seem to be stuck in time. Lucio's flat in *Rapado*, interior and exterior, is in Almagro (Valentín Gómez and Salguero Streets), other locations are in Colegiales (Plaza Juan José Paso), Recoleta (the arcade in Peña Street), Belgrano (Lucio steals the bike in Cabildo between Juramento and Mendoza). Both *Rapado* and *Silvia Prieto* (1999) focus on the *barrio* life of Buenos Aires rather than downtown. *Silvia Prieto*'s locations are mostly in Palermo Viejo. The production office and the equipment deposit were in my own house. Silvia's flat was 50 metres away, in Godoy Cruz and Honduras Streets (the soundman's place). The street protest is in Paraguay and Arévalo Streets. The prison was the workshop of painter Juan José Cambre, in Armenia and Cabrera Streets.

Since the 2000s, new, different spaces have started to appear in my films. Piraña's house in *The Magic Gloves* is in Temperley (in the Lomas de Zamora District, in the southern part of Greater

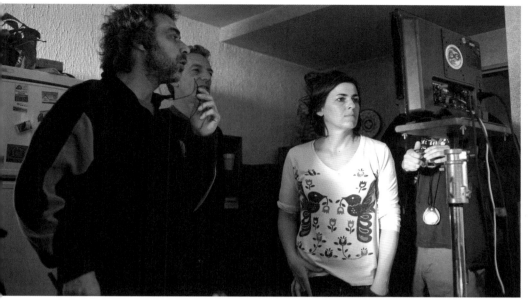

Buenos Aires), and the nightclub's interiors in Club 74 (near the River Plate stadium in Núñez). In the story, foreign porno film producers scout around for *porteño* locations for the film they want to shoot in Buenos Aires. The protagonist's voice-over recounts the locations they visited as we see the Obelisco, Teatro Colón and *villas miseria* (shantytowns). Many times my films have been criticized for showing an anonymous Buenos Aires lacking specificity. In this short sequence I wanted to equate these images of typical, touristic locations with pornography. For the documentary film *Copacabana* (2006) we filmed in the Bolivian *barrios* of Buenos Aires: Pompeya, Bajo Flores, Barrio Charrúa and Villa 11–14. Buenos Aires was revealed to my eyes as a completely unfamiliar place, which I could not have imagined existed so close to my home in Palermo.

Like other cities, Buenos Aires has changed a lot in 30 years, partly for the worse: it is dirtier, noisier, increasingly made out of poor quality materials, the streets full of traffic, and its transport system degraded. I write my

Since the 1990s, with the arrival of the big corporations, everything about filming in the city has become more complicated, with legal permits, formal requests and the like.

stories without thinking of actual locations, which makes the search long and complex. I find myself escaping the visual and noise pollution and filming more in the suburbs, which retain something of their original character. Once, the location manager didn't exist in local film-making, and Production and Art fought for locations. Now the location manager finds, manages and produces everything related to a location (including parking and catering, etc.). For *Two Gun Shots* we shot in Greater Buenos Aires, in a house in Ituzaingó with a backyard in Beccar (San Isidro) – and the interior was shot in the capital. We had so many locations (including Alto Avellaneda Mall, Parque Las Heras, downtown, Miramar) that shooting was highly complicated, some days with more than one location scheduled.

Buenos Aires has changed for the good in at least one way. When shooting *Rapado* in 1992 we spent a night in jail accused of 'loitering'. We were discussing a location (a mosaic-tiled wall where Lucio catches a bus) when a patrol car arrived and arrested us without any chance to explain. The residual authoritarianism of the dictatorship was still very strong then and everything was considered suspicious. One night shortly after, I was walking home, when two policemen stopped me and asked for my identity, destination and occupation. When I said I was a cinema director, they asked: 'Whereabouts is the cinema [theatre] you direct, then?' ✥

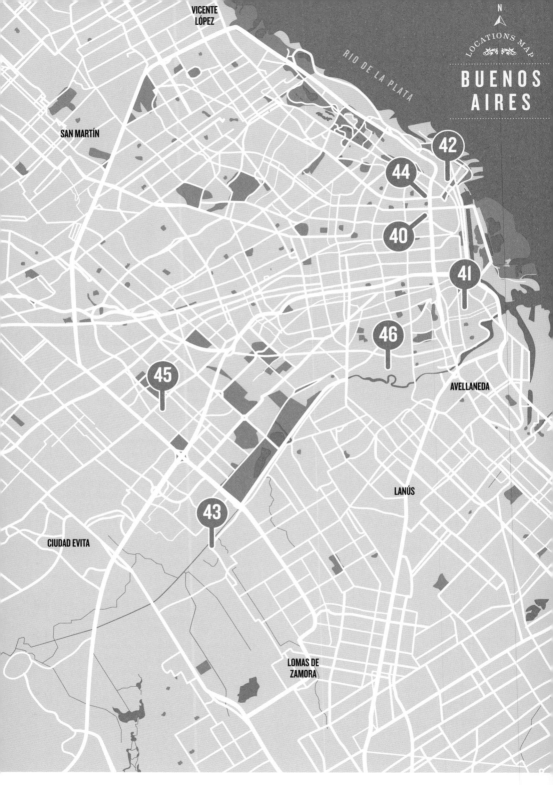

VICENTE
LÓPEZ

RIO DE LA PLATA

SAN MARTÍN

42

44

40

41

46

AVELLANEDA

45

LANÚS

43

CIUDAD EVITA

LOMAS DE
ZAMORA

BUENOS AIRES LOCATIONS

SCENES 40-46

maps are only to be taken as approximates

CAFÉ DE LOS MAESTROS (2008)

LOCATION *Teatro Colón, Cerrito 628*

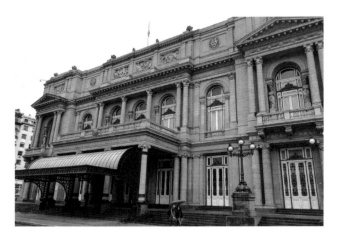

TANGO AND THE TEATRO COLÓN are perhaps the two cultural products *porteños* (Buenos Aires residents) are proudest of. Perhaps contradictorily, this attitude identifies a rich cultural heritage at both ends of the spectrum: on the one hand tango originated as a popular genre and dance in the southern *arrabales* (outskirts), and on the other the Teatro Colón represents the finest performing arts and high culture the city has to offer. *Café de los maestros*'s 25-minute finale brings tango into the Teatro Colón, featuring some of its most renowned musicians, such as Leopoldo Federico, Mariano Mores, Horacio Salgán, Virginia Luque, Atilio Stampone, Aníbal Arias, Emilio Balcarce and Gabriel Clausi. While the film resembles *Buena Vista Social Club* (Wim Wenders, 1999) in documenting the work of so many extraordinary, aging performers (in fact José Libertella and the wonderful Uruguayan singer Lágrima Ríos died before the film's release), it pays particular attention to one of tango's most fondly remembered periods: the 1940s and 1950s. This moment, which followed Carlos Gardel's death in 1935 and preceded Astor Piazzola's stylistic revolution, is usually known as the 'Golden Age' of tango. Kohan's film (produced and co-scripted by Gustavo Santaolalla) also captures the emotional investment of both the musicians and the *porteño* people, with phrases like 'I have played tango since I was born' and 'when listening to a well-played tango, if you don't shiver with emotion, something is wrong'. **↝Santiago Oyarzabal**

Photo © Marcelo Sarbia

Directed by Miguel Kohan
Scene description: Finale performance at the Teatro Colón
Timecode for scene: 0:57:49 – 1:23:41

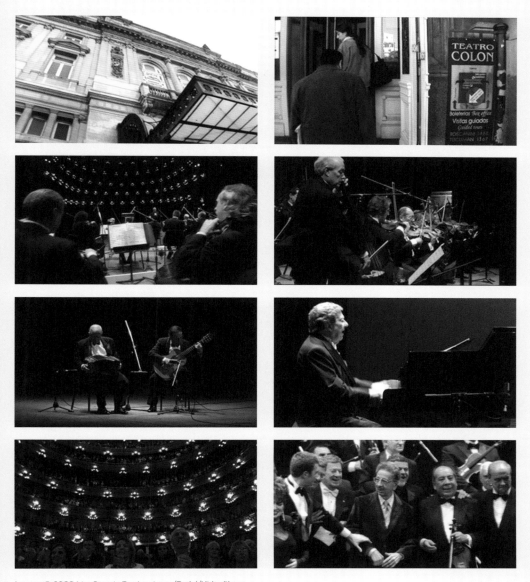

TETRO (2009)

Pinzón 1106, La Boca

LIVING IN SELF-IMPOSED exile in Buenos Aires, Tetro (Vincent Gallo) is paid a visit by his impressionable 17-year-old brother, Bennie (Alden Ehrenreich). Bennie's unexpected arrival disturbs the unassuming bohemian life Tetro has built with his girlfriend Miranda (Maribel Verdú) near Caminito in La Boca, a barrio strongly shaped by Italian immigration. Tetro does not exactly welcome him with open arms, but the morning after his arrival he decides they should reacquaint themselves by investigating the local area together, instigating a montage of perambulatory discovery. La Boca is explored with a keen eye for detail through tracking shots and high angles, autumnal streets teeming with leaves. Lensed by cinematographer Mihai Mălaimare, Jr. in sepulchral black-and-white, the sequence stylishly captures the city's abundant sensory pleasures, complemented by Osvaldo Golijov's lively accordion-centric score. Sitting down for breakfast at a graffiti-marked cafe on the corner of Pinzón and Hernandarias, Tetro introduces 'Benjamin' as his friend rather than his brother, claiming that 'people around here don't know much about me'. While Bennie is keen to delve into their tragic family history, Tetro maintains his mysterious, irascible allure. Over coffee, croissants and *pastafrola* cake, Tetro is dismissive of his brother's questions; when Bennie mimics his response, Tetro cautions, 'Don't do me. Do you. I'll do me.' Bennie is a young man who defines himself through his brother, and this scene lays the foundations for the film's exploration of fraternity and fatherhood – operatic, violent and highly theatrical, much like the animated barrio of La Boca. **↝ Adam Gallimore**

Directed by Francis Ford Coppola
Scene description: Estranged brothers Tetro and Bennie
attempt to reconnect during a walk through La Boca
Timecode for scene: 0:13:15 – 0:16:25

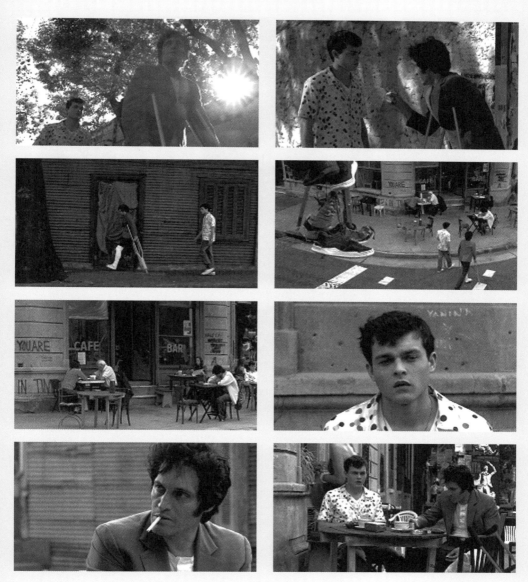

Images © 2009 American Zoetrope/Zoetrope Argentina/Tornasol

THE SECRET IN THEIR EYES/
EL SECRETO DE SUS OJOS (2009)

LOCATION *Retiro Railway Station, Av. Ramos Mejía*

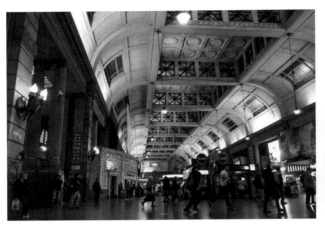

JUAN JOSÉ CAMPANELLA'S Academy Award-winning film centres around Espósito (Ricardo Darín), a retired judiciary employee who decides to write a novel about events that took place in the early 1970s, when he first met a newly minted lawyer named Irene (Soledad Villamil). His flashbacks return him to the brutal murder of Liliana Coloto (Carla Quevedo), a case on which they had both worked. Moved by the love and dedication of the victim's widower Ricardo (Pablo Rago), Espósito embarks on a quest to apprehend the murderer, enlisting the help of his co-worker, Sandoval (Guillermo Francella). This pair looks for the suspect, Gómez (Javier Godino), who manages to elude them and forces them to travel unofficially to a town in the province of Buenos Aires to discover more information about his whereabouts. Meanwhile, Ricardo maintains a constant vigil in the main train stations of Buenos Aires, watching out for Gómez among the surburban commuters. In the chosen scene Espósito spots Ricardo in the Retiro Railway Station, an impressive, cavernous example of early-twentieth-century engineering which opened to the public in August 1915. The architecture of the building speaks of wealth, culture and European influence in a neighbourhood that is also surrounded by shantytowns and busy streets. Retiro is also depicted as a place of departures and painful separations, as Espósito last saw Irene there when he departed to Jujuy after Sandoval's murder. ➛*Carolina Rocha*

Directed by Juan José Campanella
Scene description: Ricardo keeps watch in Retiro Railway Station
Timecode for scene: 0:48:12 – 0:50:31

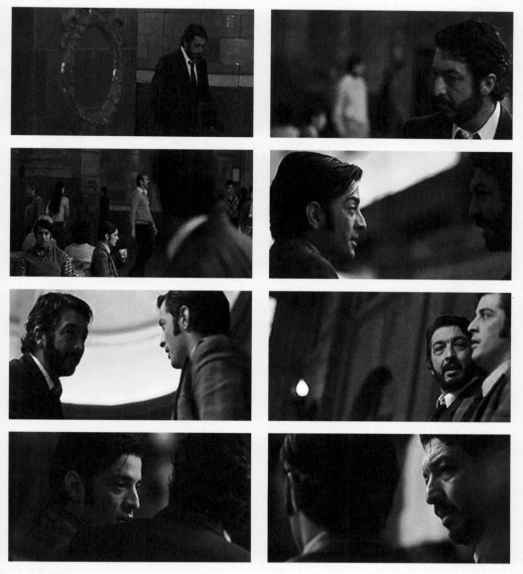

Images © 2009 Tornasol Films/Haddock Films/100 Bares

BECOME A STALLHOLDER/
HACERME FERIANTE (2010)

Feria La Salada, Lomas de Zamora District

THE SUN RISES over La Salada fair, in the south-western outskirts of the city. The polluted Riachuelo river provides the outline of this elusive, mobile space, which is assembled and dismantled every single day. Above the river, products and people pass, many crossing by foot into the main market using the iron railway bridge. This is a world that comes and goes rapidly, where hundreds of workers begin the day by building their workplace in the suburbs of Buenos Aires. And yet, no matter how precarious this fair might appear, it draws many thousands of customers each time it opens. It is a periphery that becomes a centre for a brief period. The dynamic is challenging, dense and disordered. The fair merges living folk traditions, immigrants and workers from the south of Latin America, with goods produced in the adjacent neighbourhoods, as well as imports from around the world. These will in turn be dispersed to another 200 fairs in the provinces by the wholesale buyers that attend this market. The film is a compelling observational documentary that shows how La Salada operates, how it is done and undone. It allows the spectator to investigate the nature of this 'moving point', and the ways in which it integrates new informal markets into the global economy. By looking more closely, the shape of a new economic geography can be grasped.
Luciana Zorzoli

Directed by Julián D'Angiolillo
Scene description: Morning in La Salada
Timecode for scene: 1:04:50 – 1:09:30

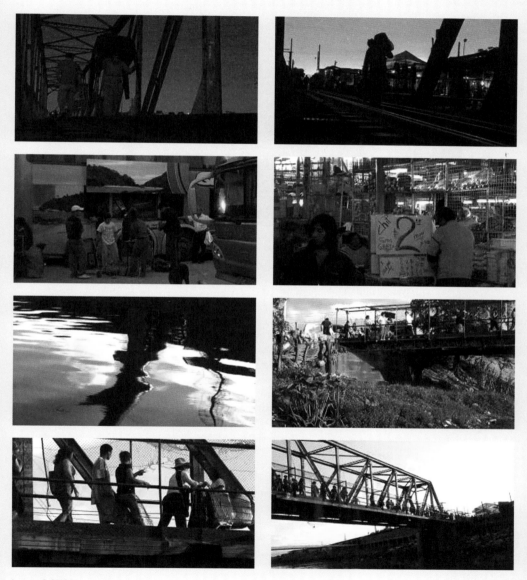

Images © 2010 Magoya Films

SIDEWALLS/MEDIANERAS (2011)

BUENOS AIRES has been called the Queen of the River Plate. However, in Gustavo Taretto's first feature-length film, the city is portrayed as an overwhelming metropolis, built amidst a proliferation of *medianeras* (sidewalls) that keep people apart. In this romantic comedy, Martín (Javier Drolas) is a phobic web programmer and Mariana (Pilar López de Ayala) a recently separated architect, who earns her living decorating shop windows. These characters are overwhelmed by the urban agglomeration and their failed romances. Both work towards overcoming their problems, slowly shedding the fetish objects – such as a male mannequin and an old desk chair – that they have used to erect unseen sidewalls around themselves. The film takes a turn when they both decide to open illegal windows in their apartments to let in more sunlight, but this promising move is still not enough for characters who are more adept at making acquaintances online than face to face. The placement of the windows, in two opposing tower blocks, is striking, surreal and comedic. This unusual look was, in fact, crafted using CGI – a digital collage based on a section of Av. Cabildo, which was earlier explicitly attributed to Santa Fe 1105 and 1183, near Cerrito. At the end of the film, Mariana sees Martín through her window and rushes to meet him on the street just below their buildings (yet the actual location is in Santa Fe and Rodríguez Peña), also redeeming Buenos Aires as a city where real encounters are possible. ➼ *Carolina Rocha*

Photos © main picture: Gustavo Tarreto / detail: Marcelo Sarbia

Directed by Gustavo Taretto
Scene description: Martín and Mariana look out of their illegal windows
Timecode for scene: 1:06:56 – 1:09:18

WHITE ELEPHANT/ELEFANTE BLANCO (2013)

LOCATION *Ciudad Oculta (aka Villa 15 or Barrio General Belgrano), Av. Piedra Buena*

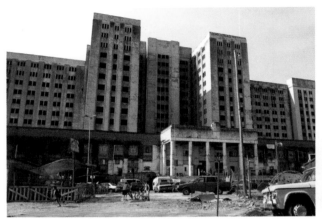
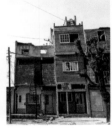

PABLO TRAPERO belongs to the 1990s group of directors that founded the New Argentine Cinema. As a native of La Matanza, one of the most deprived areas in greater Buenos Aires, he has shown consistent concern for the depiction of neglected socio-political issues. *White Elephant* follows this trend by telling the story of two Liberation Theology priests that face the difficulties of everyday life in a slum. The film includes, within its plot of faith challenges and social struggles, a sub-story of drug trafficking and addiction, along with a celebration of community spirit in the face of adverse living conditions. Although it was predominantly shot in the actual 'White Elephant' located in Ciudad Oculta (the 'Hidden City', in the General Belgrano neighbourhood), using a documentary style that gives verisimilitude to the story, many scenes were filmed in other informal settlements, such as Villa 31 and Villa Rodrigo, as if to state, through a fictionally constructed space, that this is a common reality of all slums. The imposing structure that gives the film its name reveals itself to the spectator through a long sequence shot of the walking tour that father Julián (Ricardo Darín) gives to the newly arrived foreign priest Nicolás (Jérémie Rénier), from their illegal room – with its views of the shantytown – to their chapel. The camera pauses to show us the building that was meant to be one of the largest hospitals in Latin America (before construction was halted midway through) and which now serves as the perfect location-metaphor for a city's excess and oblivion. ➻*Clara Garavelli*

Directed by Pablo Trapero
Scene description: Father Nicolás gets to know the White Elephant and its surroundings
Timecode for scene: 0:14:04 – 0:19:20

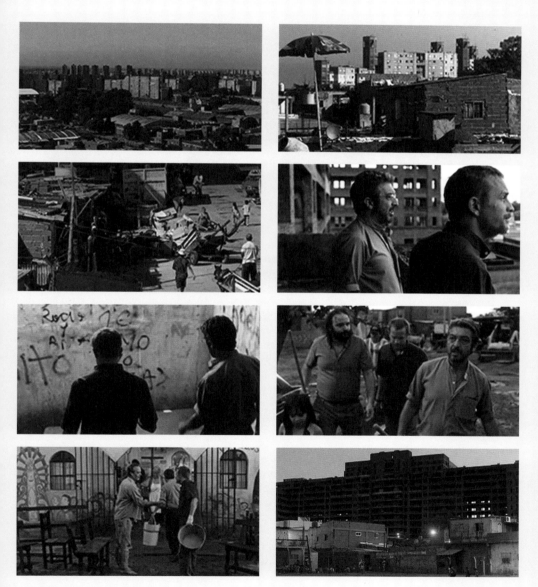

Images © 2012 Morena Films/Matanza Cine/Patagonik

VILLA (2013)

Playground in front of San Blas parish chapel, Villa 21, Barracas

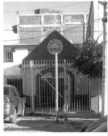

THROUGHOUT THE PAST SEVERAL DECADES and into the present the *canchitas*, or playgrounds for informal football, have been a key instrument for the articulation of community life, identity and solidarity networks in Argentine shantytowns. During the 1950s and 1960s, for example, *canchitas* and local football associations were simultaneously a vehicle for each shantytown to define its own character, and the founding stones for neighbourhood improvement committees. Furthermore, the symbolic density of the *canchita* is enhanced by the fact that it lies directly in front of the shantytown's parish chapel, the keystone of religious and charity life, and is crucially accompianied by an icon of the Gauchito Gil, a character of popular devotion in Argentina. The importance of football in the film, as a reflection of its centrality in everyday life, is not limited to the shantytown, but rather applies to society as a whole – the individual is defined by the way they play or watch it. The *canchita* reflects the specificity of the shantytown environment: the social encounters taking place here evolve into a turning point in the trajectory of one of the protagonists, Fredy (Julio Zarza), underlining the multiplicity of meanings and functions served by football for Argentine society. **↝Adriana Laura Massidda**

Directed by Ezio Massa
Scene description: Pick-up football in the canchita de San Blas
Timecode for scene: 0:09:31 – 0:15:17

GO FURTHER

Recommended reading, useful websites and film availability

BOOKS

Buenos Aires:
A Cultural and Literary History
by Jason Wilson
(Signal Books, 2007)

Buenos Aires: Historia de cuatro siglos
by José Luis Romero and Luis Alberto Romero
(Altamira, 2000)

Buenos Aires: Plaza to Suburb 1870–1910
by James R. Scobie
(Oxford University Press, 1992)

Buenos Aires: Perspectives on the City and
Cultural Production
by David William Foster
(University Press of Florida, 1998)

Cine y Peronismo: El estado en escena
by Clara Kriger
(Siglo XXI, 2009)

Confronting the 'Dirty War' in Argentine cinema,
1983-1993
By Constanza Burucúa
(Tamesis, 2009)

Crisis and Capitalism in Contemporary
Argentine Cinema
by Joanna Page
(Duke University Press, 2009)

Espejos: Una historia casi universal
by Eduardo Galeano
(Siglo XXI, 2008)

Magical Reels:
History of Cinema in Latin America
by John King
(Verso, 2000)

Miradas sobre Buenos Aires:
Historia cultural y crítica urbana
by Adrián Gorelik
(Siglo XXI, 2004)

New Argentine Cinema
by Jens Andermann
(I.B. Tauris, 2011)

Other Worlds: New Argentine Film
by Gonzalo Aguilar
(Palgrave Macmillan, 2011)

Specular City: Transforming Culture,
Consumption, and Space in Buenos Aires
(1955–1973)
by Laura Podalsky
(Temple University Press, 2004)

ARTICLES

'Un cine contemporáneo: Entrevista a Martín
Rejtman'
by Alejandro Ricagno and Quintín
In El Amante 5: 53 (1996)

'The two avant-gardes: Solanas and Getino's The
Hour of the Furnaces'
by Robert Stam. In Barry Keith Grant and
Jeannette Sloniowski (eds), *Documenting the*
documentary: Close readings of Documentary Film
and Video (Wayne State University Press, 1998)

ONLINE

'Rapado'
by Martín Rejtman, trans. *Fernando Sdrigotti*
(*Minor Literature[s]*, 12 June 2014 – first published
1992)
http://minorliteratures.com/2014/06/12/rapado/

Wikimapia map of Buenos Aires
http://wikimapia.org/#lang=en&lat=-
34.612566&lon=-58.368473&z=15&m=b

Museo del Cine Pablo Ducrós Hicken
http://museos.buenosaires.gob.ar/cine.htm

BAFICI – Buenos Aires Festival Internacional de
Cine Independiente
http://festivales.buenosaires.gob.ar/bafici

Cine Nacional
http://www.cinenacional.com/

INCAA – Insituto Nacional de Cine y Artes
Audiovisuales
http://www.incaa.gov.ar/castellano/index.php

CONTRIBUTORS

Editor and contributing writer biographies

EDITORS

SANTIAGO OYARZABAL is Associate Fellow in Hispanic Studies and currently teaches film and Latin American history at the University of Warwick. His research specializes in Argentine and Latin American film, media and cultural studies. He is currently working on a monograph based on his PhD thesis, and a number of documentary film projects.

MICHAEL PIGOTT is Assistant Professor of Video Art and Digital Media at the University of Warwick. His research focuses on experimental film and video, the city, and audio-visual cultures. He is the editor of *World Film Locations: Venice* (Intellect, 2013) and author of *Joseph Cornell Versus Cinema* (Bloomsbury, 2013). He also works as an artist named Michael Lightborne (www.michaellightborne.com).

CONTRIBUTORS

GONZALO AGUILAR is a researcher in the National Scientific and Technical Research Council (CONICET) and Professor of Brazilian Literature at the Universidad de Buenos Aires (UBA). He has been a visiting professor at Stanford, Harvard and São Paulo universities. He has worked on Brazilian poetry and new Argentine cinema. He is the author of *Poesía concreta brasileña: Las vanguardias en la encrucijada modernista* (Beatriz Viterbo, 2003), *Otros mundos: Ensayos sobre el nuevo cine argentino* (Santiago Arcos, 2005) – published in English as *Other Worlds* (Palgrave, 2008) –, *Episodios cosmopolitas en la cultura argentina* (Santiago Arcos, 2009), *Borges va al cine* (Libraria, 2010; with Emiliano Jelicié) and *Por una ciencia del vestigio errático: Ensayos sobre la antropofagia de Oswald de Andrade* (Grumo, 2010).

MARÍA AGUSTINA BERTONE was born in Tandil. She holds a degree in Audiovisual Arts and is currently an assistant professor and researcher at the School of Arts of the Universidad Nacional del Centro de la Provincia de Buenos Aires (UNICEN). Her main research focus is Argentine cinema in the 1960s.

CONSTANZA BURUCÚA graduated from UBA and completed an MA and a PhD in Film and Television Studies at the University of Warwick (UK). She then moved to Caracas, where she worked as an independent TV producer, while preparing the manuscript of her book *Confronting the 'Dirty War' in Argentine Cinema, 1983–1993* (Tamesis, 2009). In 2010, she joined the Department of Film Studies at Western University (Canada). Her research focuses on Latin American film cultures, particularly Argentine cinema, and she is also committed to the production of documentary films.

JAVIER CAMPO is a doctoral candidate and researcher (UBA), and holds a scholarship from CONICET. He is director of the journal *Cine Documental* and teaches Estética cinematográfica (UNICEN). He is co-editor of *Cine documental, memoria y derechos humanos* (Nuestra America, 2007), author of *Cine documental argentino* (Imago Mundi, 2012) and contributor to *Una historia del cine político y social en Argentina* (Nueva Librería, 2009 and 2011) and *Reflexiones teóricas sobre cine contemporáneo* (Gobierno del Estado de México, 2011), among others. He is also a member of the Centro de Investigación y Nuevos Estudios sobre Cine (UBA) and of the Instituto de Investigaciones Gino Germani (UBA).

JACK CORTVRIEND is a PhD candidate in English at the University of Sheffield. His research is focused on style and landscape in contemporary British social realist cinema. He received his MA for Research in Film and Television Studies from the University of Warwick in 2013. His interests include contemporary British cinema and music, contemporary world cinema and phenomenological film theory.

ANDREA CUARTEROLO holds a PhD in History and Theory of Arts. She specializes in the history of Argentine photography and silent cinema and is a researcher at UBA and CONICET. She is author of *De la foto al fotograma: Relaciones entre cine y fotografía en la Argentina 1840–1933* (CdF Ediciones, 2013) and has contributed to numerous books, including *Civilización y barbarie en el cine argentino y latinoamericano* (Biblos, 2005), *Cines al margen* (Libraria, 2007), *Una historia del cine político y social en Argentina* (Nueva Librería, 2009) and *Directory of World Cinema: Argentina* (Intellect, 2014).

ADAM GALLIMORE is a Research Librarian and teaches film studies at the University of Warwick, having completed his PhD in 2013. His current research focuses on historical cinema and digital film-making, and he has written book chapters and journal articles on narrative immediacy, biographical cinema, and subjectivity and film ➔

style. His work has recently been published in *Scope: An Online Journal of Film and Television Studies, Networking Knowledge* and *Exchanges: The Warwick Research Journal*. He is also an editor for G|A|M|E – *Game as Art, Media, Entertainment* and *Alternate Takes*, a website dedicated to bridging the gap between film reviewing and film criticism.

CLARA GARAVELLI is Lecturer in Latin American Studies at the University of Leicester. Her research interests include Latin American cinema and video, the limits of the moving image and issues related to visual culture and cultural studies. She has written critical texts on these subjects in national and international publications, such as *Directory of World Cinema: Argentina* (Intellect, 2014) and the journal *Studies in Hispanic Cinemas* (Intellect). She is a member of the editorial board of the Spanish film journal *Secuencias: Revista de Historia del Cine*.

CARLOS GIORDANO was born in Laboulaye, Córdoba, in 1962. He was born again in the Malvinas Islands in 1982. He is Professor of Journalism and Communications at the Universidad Nacional de La Plata (UNLP), where he also received his PhD. He writes poetry, political essays and academic articles. He has made documentary films about the Malvinas war and post-war. He has also published several books on the same theme. He enjoys sharing time, debates and dreams with family and friends.

JUAN GRIGERA teaches History of Economic Thought at the Universidad de Quilmes and Contemporary Problems in Argentine Economic History at UNLP, and is a fellow of CONICET. His work on the 2001 crisis, ECLAC (Economic Commission for Latin America and the Caribbean), deindustrialization and class formation has been published in several journals. He is an active member of the editorial board of *Historical Materialism* (London) and *Nuevo Topo* (Argentina).

JOHN KING is Professor of Latin American Cultural History at the University of Warwick. He has written, edited and translated more than twenty books on Latin American culture, and is currently completing a monograph on writers and cultural change in Argentina from 1960 to 1990. He is the author of *Magical Reels: A History of Cinema in Latin America* (Verso, 1990, new edition 2000) and co-editor of *The Garden of Forking Paths: Argentine Cinema* (BFI, 1988) and *An Argentine Passion: Maria Luisa Bemberg and Her Films* (Verso, 2000).

CLARA KRIGER received her PhD in History and Arts Theory from UBA, where she now works as researcher and lecturer. She also teaches at the IFSA-Butler University in Buenos Aires, and in the Universidad Torcuato Di Tella. Clara has authored *Cine y Peronismo: El estado en Escena* (Siglo XXI, 2009), written several articles and essays on the subject of Argentine film and has contributed to books such as *Masas, pueblo, multitud en cine y televisión* (Eudeba, 2012), *Miradas desinhibidas: El nuevo documental iberoamericano 2000/2008* (SECC/Ministerio de Cultura, 2009) and *Cines al margen: Nuevos modos de representación en el cine argentino contemporáneo* (Libraria, 2007).

CARA LEVEY is Lecturer in Hispanic Studies at University College Cork. She is currently completing her monograph, entitled *Commemoration and Contestation in Post-dictatorship Argentina and Uruguay: Fragile Memory, Shifting Impunity* (forthcoming 2014) and has published a number of papers in the *Journal of Latin American Cultural Studies, Latin American Perspectives* and in edited books. She is also co-editor (with Daniel Ozarow and Christopher Wylde) of *Argentina Since the 2001 Crisis: Recovering the Past, Reclaiming the Future* (Palgrave-Macmillan, 2014), which examines social, political and cultural responses to crisis.

ADRIANA LAURA MASSIDDA is currently a PhD candidate in Architecture at the University of Cambridge. Her research focuses on the history of urban informality in Buenos Aires and the interaction between the shantytowns and the State. She obtained her architectural training from UBA, where she graduated in 2006, and finished an MPhil at Cambridge in 2011. After some years of professional practice, Adriana began her current research as a student of King's College, Cambridge, and the Department of Architecture.

EAMON MCCARTHY is Lecturer in Hispanic Studies at the University of Glasgow. He specializes in twentieth-century Argentine visual and literary culture, with a particular focus on the historical avant-garde.

RAMIRO MONTILLA graduated from the University of Warwick with a degree in Sociology with a specialism in Cultural Studies. He studied social communication at UBA. As a freelance writer and journalist, he has written several articles for *Sport360*.

CAROLINA ORLOFF is a scholar currently researching the literature, cinema, culture and politics of contemporary Argentina. She graduated from the University of York with a degree in English and Philosophy and then received her MA in Literary and Film Translation from the University of Leeds. Her PhD in Latin American Literature was awarded by the University of Edinburgh. In addition to her publications on Argentine cinema and translation theory, Carolina has published extensively on the writer Julio Cortázar, , including a monograph. She is currently a Postdoctoral Fellow at IASH, University of Edinburgh.

MARIANA OYARZABAL is a certified English translator (UNLP) and works as a freelance translator and teacher. She currently works for the Centro Azuleño de Cultura Inglesa. In 2010 she joined the Language Department of UNICEN where she teaches English as a foreign language and assists researchers on research papers and academic activities.

JOANNA PAGE is Senior Lecturer in Latin American Cultural Studies at the University of Cambridge. She is the author of *Crisis and Capitalism in Contemporary Argentine Cinema* (Duke University Press, 2009), *Creativity and Science in Contemporary Argentine Literature* (University of Calgary Press, 2014) and a

forthcoming book, to be published with the University of Michigan Press, provisionally entitled *Technologies of the Text in a Material Multiverse: Science Fiction from Argentina*. Her current projects include Chilean cinema and graphic fiction from Latin America.

MARIANO PAZ is Lecturer in Spanish at the University of Limerick (Ireland). He holds a degree in Sociology from UBA and completed a PhD at the University of Manchester, with a thesis that explores dystopian representations in Argentine films. He has published several articles on politics and society in Argentine science fiction cinema.

NATÁLIA PINAZZA is Associate Lecturer at Birkbeck College, University of London. She completed an ORSA (Overseas Research Students Awards) funded PhD in Argentine and Brazilian cinema at the University of Bath. She has co-edited the volumes *World Film Locations: São Paulo* (Intellect, 2013) and *Directory of World Cinema: Brazil* (Intellect, 2013). Her monograph *Journeys in Argentine and Brazilian Cinema: Road Movies in a Global Era* will be published by Palgrave Macmillan in November 2014.

PAULA PORTA is a teacher and researcher at the UNLP, where she convenes the Comunicación y Media module. She is the director of the research project 'Gestión online/offline del arte: Transformación en los modos de gestión, producción y circulación de las intervenciones artísticas' (2013–14). She has published widely in media and communications studies.

MARTÍN REJTMAN is an award-winning film director. He studied film-making at New York University and currently lives and works in Buenos Aires. His first film, *Rapado* (1992/1996), is often praised as seminal to what critics have called the New Argentine Cinema. His most recent film is *Two Gun Shots/Dos disparos* (2014). He is also a writer, and his short story 'Rapado' has been translated into English by Fernando Sdrigotti.

CAROLINA ROCHA is Associate Professor at Southern Illinois University Edwardsville. She holds a PhD from the University of Texas at Austin. She is the author of *Masculinities in Contemporary Argentine Popular Cinema* (Palgrave Macmillan, 2012) and editor of *Modern Argentine Masculinities* (Intellect, 2013). She has also co-edited several volumes: *Violence in Argentine Literature and Film* (University of Calgary Press, 2010) with Elizabeth Montes Garces; *New Trends in Argentine and Brazilian Cinema* (Intellect, 2011) with Cacilda Rêgo; and *Representing History, Class and Gender in Spain and Latin America: Children and Adolescents in Film* (Palgrave Macmillan, 2012) with Georgia Seminet.

LUCÍA RODRÍGUEZ RIVA is a graduate in Arts (UBA) and an audio-visual producer (TEAImagen). She is a researcher and lecturer in Argentine and Latin American cinema at UBA and at the Instituto Universitario Nacional del Arte. She is co-compiler and author of *30-50-70: Conformación, crisis y renovación del cine industrial*

argentino y latinoamericano (FFyL-UBA, 2014). She has published articles and reviews in specialized journals focusing on classic and contemporary Argentine cinema. She works on the recovery of audio-visual heritage through the Amadori Collection. As a producer, she has been involved in documentaries and television programmes.

SAMANTA MARIANA SALVATORI was born in Campana. She teaches Social History of Argentina at UNLP. She is co-author of *La Última dictadura military en Argentina: Entre el pasado y el presente* (Homo Sapiens, 2009) and *Efemérides en la memoria* (Homo Sapiens, 2012) and has published on cinema, human rights and recent history. At present, she directs the programme on Research in the Commission for the Memory of Buenos Aires Province.

JAMES SCORER is Lecturer in Latin American Cultural Studies at the University of Manchester, where he is co-director of the Centre for Latin American and Caribbean Studies. His research is centred on the urban imaginaries of several Latin American cities, including Mexico City and Lima but principally Buenos Aires. He also works more broadly on visual culture, and has published on photography, film and comics.

FERNANDO SDRIGOTTI is a writer and cultural critic. He was born in Rosario and now lives and works in London. His forthcoming book *Shetlag: Una novela acentuada* will be published by Araña editorial, Valencia, in late 2014.

ANA SILVA has a BA in Social Communication and a PhD in Social Anthropology, and currently teaches on the course Realización Integral en Artes Audiovisuales at UNICEN. She is an Assistant Researcher at CONICET in the programme Núcleo de Producciones e Investigaciones en Comunicación Social de la Ciudad Intermedia (ProInComSci UNICEN). She has worked on photography, cinema and urban imaginaries. She has published several articles and edited the compilations *Políticas, comunicación y organizaciones en la primera década del milenio* (UNICEN, 2011) and *Ensayos sobre arte, comunicación y políticas culturales* (UNICEN, 2012).

LUCIANA ZORZOLI is a PhD candidate at UBA and fellow of the Instituto de Investigaciones en Humanidades y Ciencias Sociales (UNLP – CONICET). She currently teaches Contemporary History at UNLP. Her main interest is in trade unions during transitions to democracy and she is currently completing her dissertation, entitled 'Debatir los sindicatos el modelo sindical desde la dictadura'.

FILMOGRAPHY

All films mentioned or featured in this book

Abasto Market/Mercado de Abasto (1955) — 24
Arrabal Melody/Melodía de arrabal (1932) — 9
Barrio gris (1954) — 22
Become a Stall holder/Hacerme feriante (2010) — 116
Behind a Long Wall/Detrás de un largo muro (1958) — 48
Blade Runner (1982) — 88
Blessed by Fire/Iluminados por el fuego (2005) — 100
Bolivia (2001) — 69, 86
bonaerense, El (2002) — 69, 92
Boss, The/El jefe (1958) — 32
Buena Vista Social Club (1999) — 110
Buenos Aires (1958) — 26, 49
Buenos Aires Rock (1983) — 28
Café de los maestros (2008) — 9, 110
Candidate, The/El candidato (1959) — 49
Children of Fierro, The/Los hijos de Fierro (1975) — 49
Children of War/Los chicos de la guerra (1984) — 29
Condor Crux, the Legend/
Cóndor Crux, la leyenda del futuro (2000) — 5, 89
Copacabana (2006) — 107
Day You Love Me, The/El día que me quieras (1935) — 9
Doli Goes Home/Doli vuelve a casa (1984) — 106
Downward Slope/Cuesta abajo (1934) — 9
Evita (1996) — 64
Fantasma (2006) — 102
Felicidades (2000) — 82
Four Horsemen of the Apocalypse (1921) — 8
Frida (2002) — 8
Garage Olimpo (1999) — 78
Gaucho Nobility/Nobleza gaucha — 8, 12
Girl from the Arrabal, The/La muchacha del arrabal (1922) — 9
Girlfriend, The/La amiga (1988) — 29
Happy Together/Chun gwong cha sit (1997) — 66
Hardly a Criminal/Apenas un delincuente (1949) — 20
Hour of the Furnaces, The/
La Hora de los hornos (1968) — 38, 49
Invasion/Invasión (1969) — 5, 40, 88
Kidnapper, The/El secuestrador (1958) — 49
L'Age d'or (1930) — 38
La vuelta al bulín (1926) — 14
Last Days of the Victim/
Los Últimos días de la víctima (1982) — 68
Lost Embrace/El abrazo partido (2004) — 69, 94
Lost Republic, The/La república perdida (1983) — 29
Magic Gloves, The/Los guantes mágicos (2003) — 106

Maradona by Kusturica (2008) — 104
Metropolis (1927) — 6, 74, 88
Moebius (1996) — 62, 88
Motorcycle Diaries, The/Diarios de motocicleta (2004) — 96
Mr and Mrs Smith (2005) — 8
muertos, Los (2004) — 102
Nine Queens/Nueve reinas (2000) — 68, 80
Official Story, The/La historia oficial (1984) — 29, 52, 68
Owners of Silence, The/Los dueños del silencio (1987) — 29
Plague, The/La peste (1992) — 5, 56
People at Table 10, The/Los de la mesa 10 (1960) — 34
Pizza, Beer, and Cigarettes/Pizza, birra, faso (1998) — 68, 72
Power of Darkness, The/El poder de las tinieblas (1979) — 28
Ragged Football/Pelota de trapo (1948) — 18
Rapado (1992/1996) — 58, 106, 107
retirada, En (1984) — 28, 44
Scent of a Woman (1992) — 8
Secret in their Eyes, The/El secreto de sus ojos (2009) — 114
Shall We Dance (2004) — 8
Sidewalks/Medianeras (2011) — 69, 118
Silvia Prieto (1999) — 106
Sleepwalker, The/La sonámbula (1998) — 74, 88
Son of the Bride, The/El hijo de la novia (2001) — 68, 84
South, The/Sur (1988) — 9, 29, 54
Stars/Estrellas (2007) — 49, 89
Suburbio (1951) — 48
Take, The (2004) — 98
Tango (1998) — 9, 76
Tango argentino (1900) — 8
Tango Lesson, The (1997) — 9
Tangos, the Exile of Gardel/
Tangos, el exilio de Gardel (1985) — 9, 54
Tetro (2009) — 112
Three Amateurs, The/Los tres berretines (1933) — 16, 46
Three Times Ana/Tres veces Ana (1961) — 36
Time for Revenge/Tiempo de revancha (1981) — 28
Traitors, The/Los traidores (1973) — 42
True Lies (1994) — 8
Two Gun Shots/Dos disparos (2014) — 106, 107
Waiting for the Hearse/Esperando la carroza (1985) — 46
Wall of Silence, A/Un muro de silencio (1993) — 29
White Elephant/Elefante blanco (2012) — 49, 120
Wild Horses/Caballos salvajes (1995) — 60, 68
Villa (2013) — 122